THE WORLD NEEDS YOUR ART

So many of the problems with making a career out of art are mental. Being an artist is for the mentally strong. You have to have a nimble mindset that allows for adaptation and growth. Fournier's book is chocked full of both concrete activities and thought experiments that will help you break down or jump over or magic away the mental barriers that get in our way as artists.

I can see having this book on your shelf and turning to it when you're feeling stuck.

—**Cory Huff**, founder of *The Abundant Artist*, author of *How to Sell Your Art Online*

This book came to me at the right time in my career. The author's voice is infused with the perfect amount of humor, real talk, magic, and inspiration. I will definitely be finding my own "perfect pair of pajamas" as I dive further into my own creative destiny! Do yourself a favor and read this book.

—**Kelly Godell**, *Actress*

Writers, musicians, and artists in all walks of life sometimes suffer from the occasional inability to connect with their creative self. Writers refer to this as "writer's block." Danielle E. Fournier has written a book that offers a sane approach to rediscovering and exploring the creativity you were born with. By showing the artist/author methods for "slaying belief dragons" and using "casual magic," Fournier's book gives us tools to open the blocked channels to free our artistic voice, allowing us to employ our

talent and enjoy every moment of it. I highly recommend this to every author or artist who is struggling in their craft. I also recommend it to those who are doing well–Fournier's insights into the challenges that minimize and devalue our creative self resonated with me. This is a book I will have on my nightstand.

— **Connie J. Jasperson**, author of *Life in the Realm of Fantasy,* www.conniejjasperson.com

Have you ever wanted to write, to paint, or be the actor you know you are? Is there something holding you back? I recommend reading Fournier's book, which might provide the key to your conundrum. The arts are for you, whatever your genre. This book will help you look at options in a humorous and easy way, guiding you through the process of self-discovery and magic. Good or bad, it is all about your art.

— **Victoria Walker**, *Artist*

THE WORLD
NEEDS YOUR ART
Casual Magic to
Unlock Your Creativity

DANIELLE E. FOURNIER

NEW YORK

NASHVILLE • MELBOURNE • VANCOUVER

THE WORLD NEEDS YOUR ART

Casual Magic to Unlock Your Creativity

© 2017 **DANIELLE E. FOURNIER**

Published in New York, New York, by Morgan James Publishing in partnership with Difference Press.. Morgan James and The Entrepreneurial Publisher are trademarks of Morgan James, LLC. www.MorganJamesPublishing.com

The Morgan James Speakers Group can bring authors to your live event. For more information or to book an event visit The Morgan James Speakers Group at www.TheMorganJamesSpeakersGroup.com.

Shelfie

A **free** eBook edition is available with the purchase of this print book.

CLEARLY PRINT YOUR NAME ABOVE IN UPPER CASE

Instructions to claim your free eBook edition:
1. Download the Shelfie app for Android or iOS
2. Write your name in **UPPER CASE** above
3. Use the Shelfie app to submit a photo
4. Download your eBook to any device

ISBN 978-1-68350-373-6 paperback
ISBN 978-1-68350-374-3 eBook
Library of Congress Control Number:
2016919702

Cover Design by:
Rachel Lopez
www.r2cdesign.com

Interior Design by:
Bonnie Bushman
The Whole Caboodle Graphic Design

Editing:
Maggie McReynolds

Author Photo Courtesy:
Lehua

In an effort to support local communities, raise awareness and funds, Morgan James Publishing donates a percentage of all book sales for the life of each book to Habitat for Humanity Peninsula and Greater Williamsburg.

Get involved today! Visit
www.MorganJamesBuilds.com

DEDICATION

To Lexi, Alex, and Ellery: may every wish come true
And to my Dad, wherever you may roam

TABLE OF CONTENTS

INTRODUCTION

Without art, the crudeness of reality would make the world unbearable.
—George Bernard Shaw

Elli wants to make children's book—a Stellaluna-*type book. No, the NEXT* Stellaluna *book. She loves to draw. She carries her sketchbook with her everywhere. She wears colorful clothing and sometimes outrageous outfits, blending color any way she chooses. She is a lively nanny for three small children who adore her because she creates awesome games and laughs all the time.*

She sees the world as a fun, imaginative place to live, where white knights still reign and the Arthurian code of conduct is as

good as law. She often makes up tales for the kids to act out during their free afternoons.

The only problem is, making art might not pay the bills. Being a nanny is fun: she gets to travel and it pays well. Trading it for terra incognito *would be irresponsible. Her mom is sick. She doesn't have time. She's getting married, and she wants to be debt-free going in. She has lots of excuses why art is a bad idea.*

She takes the kids to the bookstore each week. Walking the rows of brightly decorated covers, she thinks about how many pages she'd need, what colors to choose, how thick the paper would need to be to support the full-detail scenes. She thinks about how she can teach so many children her knightly ethos, if she could ever get started.

She gets teary. What about her stories, her art? Will she ever get a chance to even try making something so big? Where would she even begin?

If this speaks to you, you are an *artist*.

You might be an artist in waiting, a creative dabbler, or a shadow artist, one that helps other artists by publishing, managing, or representing creative types. However, the story above upsets you. That nagging voice in her head is the same as the one you hear in yours. And even when it quiets down, say when you *make* something, it never really shuts up.

The creative soul needs expression, even if only unto itself. You did not choose to be an artist, it chose you. Doing anything that circumvents or denies that fact will only bring frustration, anger, and pain. Addiction, obsession, drama, suffering—they all come from a failure to meet your creative needs. Certainly not all life pain comes from suppression of creative urges, but a

large number of inactive artists suffer needlessly when they can't or don't create. It's who and what they are.

Living as an artist or having a creative life doesn't necessarily mean making your living from art sales, but that certainly can be the case if you wish it to be. At no time in history has it been easier or more acceptable to make one's heartfelt desires and talents into a fulfilling and often lucrative career. With the advent of the internet and social media, sharing your work with a wide audience has never been easier.

The question is, are you ready?

You don't have to be perfect. You don't have to be a prodigy or the best at your craft. You do need, however, to be present. Show up, do your work, and fling it ever so gently into the universe.

You might be living a life that has art on the side, art as side dish, or creativity as something you get to do when you put together beautiful lunchboxes for your children as they sleep. You may throw together outfits that look like they came from a fashion magazine, decorate your home down to the last detail, or create gardens worthy of photo shoots. You may think you have no time. You may think you have no right. You may think art was a dream that has faded or died, but it never will. It won't ever die because *you* are the artist. As long as you roam this great wide planet, you will be an artist.

I have been the girl who decided to get the law degree so I would have a "real" job. I pushed aside my talents and desires more times than I can count, all in the name of reason. But as they say, wherever you go, there you are. No matter how much money I made, how many things I bought, no matter how many

countries I visited trying to assuage the feeling that something was simply not quite right, I never could shake the feeling that there was something more for me out there. Something I was meant to do, make, or be.

For better or worse, it all came crashing down in a series of events. My younger brother was in a horrible diving accident that left him paralyzed at 31. The financial crisis of 2008 forced me to accept a job in sales that seemed like a hell come true (but a hell that paid well). I was pretty unhappy, but I played guitar at night to get by, and that was enough for a while. I was trying to be "realistic" and "smart" about my life.

Then my Dad died. I took over his publishing company, which allowed me to work with talented writers all day long. Being around passionate people doing what they loved made me...angry. I wanted to be writing, painting, singing, dancing–not watching others do it.

I put in for a sabbatical and set off to paint for three months in California. On the third day of my trip, I broke my foot. My three-month sabbatical quickly turned to six (it was a really bad break). It turned out to be just the "break" I needed.

I had nothing to do, but I did have an easel. I had recently started painting, just for fun, in my hotel rooms while I traveled. To my surprise, I found it mesmerizing and I wasn't half bad. I had never been great at drawing, so it was shocking to find that I could express myself in paint.

So began my life as a full-time artist. By the time my sabbatical was over, I was over office life. I loved making my own schedule, and found I got more done when I planned my day myself. I kept my position at the publishing company

because I loved it even more now that I was also working as an artist. My days were filled with creative thinking and doing, if not necessarily creative endeavor like painting or writing. Most of all, I was finally finding peace with my inner artist.

This book is a look into some of the blocks, practices, and myths, and methods that make a creative life both challenging and fulfilling. We'll explore how to create practices that support you, how to handle hard moments like failure, rejection, and blocks. You will develop a sense of who and what your artist wants and needs in order to thrive as you read through the pages and do the exercises at the end of each chapter. Then, you are free to make choices about what feels great and not so great, and which types of activities are total duds. Just like a snowflake, no two artists are alike, so feel free to make it up as you go.

As far as how to use the book, I recommend keeping a journal handy. Answer the questions, write down any *ahas,* and be prepared for some stunning new ideas from your artist about how to go about "arting" in this world. There are exercises at the end of each section, each one containing a mixture of three elements of what I call Casual Magic: method, madness, and mystery. Method is meant to activate your left-brain drill sergeant and satisfy any need to organize, identify, quantify, etc. Madness facilitates your right brain unloading its wordless wisdom onto your palette in an expressive manner. The last one, mystery, is a little cosmic shot of woo/faith/something wonderful that adds the element of wonder and surprise into your activities, just because. Combine them all together, somewhat casually by adding a dose of imagination and fun,

and you have an elixir for the mind, imagination and spirit, that well, works like magic!

All along the process, you will never be alone. If you get stumped, frustrated, confused, fearful, or EXCITED, head on over to my website, www.daniellefournier.com, where you can contact me, post your creations from the exercises, and interact with the community.

Have fun! Bless you and your artist. It may seem like a broken road you are traveling, but with your artist as your guide, you'll always be headed in the right direction.

Chapter 1

DIVINE INTERVENTION

I Have Nothing to Declare But My Genius
— **Oscar Wilde**

The Call

Welcome.

I believe every person on this planet has a unique set of skills, talents, sensibilities, and gifts. I believe you have the gift of creativity. Maybe you are a dancer, a singer, and actor, a painter, an illustrator, a writer, or a flower arranger—you could be any of those wonderful things. Maybe you don't call yourself an artist, but have an artistic way of looking at and being in the world. You are still an artist on the inside. Whether

it's decorating a cake, or putting together gorgeous outfits, or creating a garden that looks like it came from a magazine, you make everyday things beautiful.

Whatever you call yourself, hands down, you are a person who can make something out of nothing. Where once there was shadow, flats and a ghost light created a forest. Where once was open wood floor, a swan came to life *en pointe*. Where a vast white canvas once waited patiently, a garden bloomed.

All this happened because of you.

At some point in every artist's life, there comes a dry season. Often this happens mid- and early career when there is so much at stake, But it also happens to some degree on a day-to-day basis for all people who create things. You may not be working as an artist, but I will bet you are thinking about how your creative nature could be part of your daily life. Perhaps, though, you worry that your creativity is a fleeting and unreliable resource.

I can assure you that it is not. In fact, your creativity wants to be your best friend. And best friends can be counted on, provided you treat them with the respect that they deserve.

There are many reasons the river of creativity slows. I encourage you not to consider it like a tide, with ebb and flow according to the moon (I will explain this later). The creative flow, what I call the Art Flow, is like a river with a dam. The rate of water released relies upon how open the floodgates are— or aren't.

Chances are, you have made a piece of art that came so easily you wondered if you copied it from somewhere, or if you

had learned it before, or seen it in a movie. It appeared like it *wanted* to appear. It seemed to come from nowhere.

It is also likely you have created something that felt like pulling teeth. Whether you were on a deadline, doing a commission, or just baking a cake for your sister's birthday *that would not come out right no matter how hard you tried*–you have experienced being out of flow.

Some people call them blocks. I call them rocks. And you, dear creator, are the water that is going to flow right on by those boulders.

Stopping the Flow

There are lots of reasons your creative flow can slow to a trickle. Sometimes it's a simple structural problem like a less-than well-though- out idea, and sometimes it's a massive heartbreaker like losing your dad. Whatever it is, feeling stuck stinks.

Remember when I said you shouldn't think about your creativity like the tide? Well, the moon influences the tides. Depending on where you are in the moon's cycle, you could be walking a beautiful moonlit path or stumbling along in the dark.

As a lifelong artist, I have run into countless breaks in the flow of my work. From forgetting lines to not wanting to sign my work because I thought it sucked, here's a list of days it didn't flow so well:

- stuttering while reading aloud so badly that my friend, who was sitting behind me, had to take over

- dancing in the back row in hula because I would get so nervous at performances I would forget the choreography, every time
- having a great audition set up and actually turning up just to tell the interviewers I *wasn't* auditioning because *I wasn't ready*
- never even trying to audition for leads in plays because I *knew* I would forget my lines
- blowing a commission I had months to do because I was fixated on getting one ear on a dog perfectly right, only to have the client buy the "test" version off Facebook
- moving to Southern California to "find my art" and promptly getting into a horrible relationship
- finally grieving losing my dad enough to start painting six hours a day, only to have my dog get serious cancer

The list goes on and on. It's true for many creative people because *life happens.* What's amazing about Art Flow is that it just keeps showing up. It doesn't really care about your life's circumstances; it cares about *you.* Your art wants to nurture you in life. It is your essential self, part of your inner being. You cannot separate yourself from it, and because of that, it cares about you as a person.

Think of a time when a creation just appeared out of nowhere. You were doing something else. You were just playing. You were folding laundry. You were helping your kids draw. And then, *wham!* An idea.

Here's a few times this has happened to me:

- sitting in a bar in Edinburgh, I get a whole novel concept when looking at a green flame
- one day, I try to draw a lovely portrait of my horse, only to get bored and turn him into a dragon that becomes a children's book
- for no good reason, I take a painting class and end up loving it so much I turn my life inside out to pursue it (and it sells!)
- I search for an after-work dance class, find a lifelong love of hula, a partner of five years, and a band to sing in—plus I learn to play better guitar and ukulele
- responding to my voice teacher's need for a mezzo in a play only to meet one of my creative soul mates

This list goes on and on as well. The truth is, my muse has never let me down. Not once. Zip. Nada.

She might be slow to the call, or bizarrely inspired, but she always shows up.

Here's why: I control the flow. Art is my life and blood. It's how I eat, sleep, live, and even love. It's my dreams, hopes, and deepest desires. I can't *not* do it.

Wait, that's not true. I can. And heaven knows there are consequences. Ice cream eating consequences. Extra degrees in college consequences. Bad boyfriend consequences. Shopaholic consequences. Angry enough to go to the gym at 8 p.m. so I don't eat the ice cream consequences. Quietly giving up going to the movies because I want to write the movie, not watch someone else's dream consequences.

What are your consequences?

Do you feel like you should be doing some artful thing? Do you wake up at night wondering if you will ever write the book? Or try acting again? Or do you tear up when you drop your daughter off at ballet, remembering the feel of running into the room, thinking, *I will get my plié perfect today*? Or maybe you were like me, quietly shepherding along other artists while secretly thinking, I could totally rock this, if only… if only.

If only. That's where we get stuck. We want it to be perfect. We want ourselves to be perfect. We want the world to be perfect before we can begin.

Well, it's not. We're not. It's not a perfect world, either.

And this is where the magic happens—when we start to control the flow. Think about that river. Whether you want a ripping whitewater ride or a sere sail, you have to put your boat on the water at some point.

It truly doesn't matter if you are a teen or an octogenarian, it is never too late to be in your Art Flow. Being creative is who you are.

With Great Power Comes Great Responsibility

Let's consider Spider-Man. Being Spidey is his art (don't hate if you are a DC fan, love me some Wonder Woman). Who would he be without his adventures? Sure, Peter Parker is cute, loves his family, and has his share of love interests, but his life comes into focus when he puts on his suit. Swinging from building to building, he uses his genius intellect and spider sense to fight crime, get the girl, and save the world. And he has a fine time doing it.

Not only would Spidey be missing out as dull Peter Parker, he would be ignoring his calling. As an artist, you too have a great responsibility.

You need to share your gift.

You may be thinking that being an artist isn't as important as being a banker or a lawyer or even an upstart entrepreneur. That may be what the world tells you, and there may be lots of evidence to support that theory. However, do you really believe that?

Do you not look at *Swan Lake* or *Game of Thrones* or *Lady Liberty Leads the People* and think, *dang, I wish I had made that*? Not only because it's a cool expression of color or rhythm or design, but because it speaks to people? Great art, in my belief, is about connecting people on the level of their humanity.

Artists get to share their gift of connection with the world when they create their work. It doesn't matter if the work is on a small or large scale, what matters is that it gets done. It does not matter if you get paid or not, your art will want to come out. Old or young, a mother, a father, a grandparent, a teacher, or a teenager, no matter where you are in life or what role you are playing, your art will want a voice. You will always be making something, decorating something, singing something, writing something, because it is who you are, not just something you do.

Ask yourself this question: why would you have a gift that if it is never meant to be used? Who is it for? Why do you have it? What is it meant for? Who is it meant to heal? To help? Listen to the answers that come; these are the people who need

your work. You are making the world a better place by sharing perfect, beautiful you.

Limiting Beliefs

It's time to slay some Belief Dragons. (I love dragons, don't get carried away.)

Belief Dragons are beliefs that are well, frankly full of hot air. These are the words and thoughts that run around inside your head that are holding you back from your quest. Liming beliefs can be thoughts like:

> Artists are crazy
> Artists are broke
> Art is a talent you are born with
> Making art is irresponsible
> Art is not a job
> Artists are lazy
> Making art is hard/weird/selfish
> Creativity is for children, not adults

There are many myths around creativity and the way art is created. Any artist will tell you they have a system, even if that is not a system they can describe. Because the Art Flow comes from within, it can often feel as though it either has no reliable source (like Serendipity), or is granted by some otherworldly power (like The Muse). Either way, because of this belief that art has no visible source, it has gotten a really bad rap in modern

culture as being unreliable, and therefore, an untrustworthy and unbankable option of serious adult pursuit. Read: BAD career choice.

Well, have I news for the world. Artists are chosen by their art, just like athletes and mathematicians. We believe the limiting thought because we think it will keep us safe, but really, it just makes us sad. Or miserable. Or both.

So, let's just suspend a little disbelief here and ask ourselves: *what if?* Just for a little while, let's believe art is a respectable, predictable, and steady means of expression that elevates humanity every time someone picks up a paintbrush. When you are done with this book, you can choose to keep or drop your beliefs about art, but for now, let's just write them down and put them into a container that will act like Kryptonite to them. They can't affect you on this planet. They have no power when they are inside that jar.

Below are some exercises to discover some of your ideas around you and your art.

Casual Magic: My Purpose Is...

Write the statement *My purpose is... (fill in the blank)* ten times, answering with whatever comes to mind.

Example: *My purpose is to share the beauty I see with the world,* or *My purpose is to capture the light.* It's okay if it is the same each time or different every time. What did you discover?

Casual Magic: My Secret Wish Is...

Now write the statement *My secret wish is... (fill in the blank)* ten times, answering with whatever comes to mind. Again, it's okay if it is the same each time or different every time.

Example: *My secret wish is to play a pants part (falsetto role in opera),* or *My secret wish is to learn ballet,* or *My secret wish is to fly helicopters.* Did you find a hidden desire? Or one you knew was lurking under the surface?

Casual Magic: 10 People
I Want to Be Because...

List 10 people you would like to be. This could be a profession (fireman, fishing guide, baker) or an actual person (Marilyn Monroe, Jackson Pollock, Albert Einstein). Then state a reason why. Fill in the blanks writing *I would like to be... because...*

Example: *I would like to be like Johnny Depp because he gets to have fun being a pirate and wearing lots of eyeliner as Jack Sparrow,* or *I would like to be Mary Oliver because she expresses the miracle of nature through poetry,* or *I would like to be a fishing guide in Alaska because they get to be outside all day.*

Did you discover any theme, like a need for solitude or more color. or an interest in beading?

Chapter 2

GETTING STARTED WHEN YOU ARE AFRAID

Every child is an artist. The problem is how to remain an artist once we grow up.
—Pablo Picasso

No Art, No Problem!

A blank page. An empty bowl. A wide expanse of floor. A ball of yarn. Three yards of fabric. A mound of clay. A pile of wood. These are all materials full of possibility and promise.

Unless you have no freakin' idea what to make with them! Then that wide swath or red satin or ripe bowl of cherries or

great new score your friend wants you to choreograph can swiftly turn from dream to nightmare.

No art, no problem! I say, *because it WILL show up/ return.* How fast becomes a matter of how much you are willing to open up, soften, let go and be willing to risk feeling a little vulnerable. Let's start by looking at what a creative block is, anyway.

First and foremost, it's important to stop treating a block of any kind as anything but a self-created wall. *And that is absolutely ok, because you can just take it down, brick by brick.* You are in control. You have the power inside of you, always. I promise, on my life, your muse wants to come play. Even if you have never had a muse before, trust me, she wants to come play with you. Right now!

Now, here's the hard part. You are creating the resistance within you to letting your creativity flow. I am so sorry to tell you this, but you are the problem. And you are also the solution.

This is so empowering, because once you get the hang of distracting your inner critic, you will be able to access your creativity and art much, much faster.

Many artists suffer from art blocks, from failing to start projects or finish them to changing direction wildly mid-project to fostering undermining tendencies. These are all caused by limiting beliefs around the process, the artists and the art.

Your art wants to appear. Creativity wants to bubble up from our depths. When it doesn't do so easily, we say we have a block. And a block is every artist's fear.

Artists fear blocks because they are afraid that 1) they may not have any real talent, or 2) that the block will last forever and they will never create again.

None of this is true whatsoever.

In my experience, hiccups about starting/resuming projects come from limiting beliefs and fears. Beliefs include thoughts like *I should be better at this, I am not good enough, I might go crazy,* or *all artists are broke.* Working practices can also create blocks like bad working habits, rushing or waiting too close to a deadline, and tolerating interruptions that can waylay your progress, sometimes even grinding it to a halt.

It certainly can be very scary, and feel absolutely real, to let beliefs rooted in fear get in the way of you being creative. I know it definitely held me back from my biggest dream at one point.

My Story of Stage Fright

I always loved to sing. My parents were both amateur musicians, and I grew up in a house with more music than television. Friday nights were spent turning up the stereo and holding dancing/singing parties to everything from ABBA to Steely Dan to John Denver (as we became teenagers that turned into Van Halen and Jimmy Buffett). Singing was something that came naturally to me. I even remember the first song I ever really learned to sing along to on the radio. It was *Radical* by Supertramp (However, I thought it was *Ratical,* a song about the Chuck E. Cheese mouse, which increased my five-year-old fervor). Like a typical teen, my room was covered in music

posters, not just because I was in love with Duran Duran's John Taylor, but *because someday I was going to be one of them.*

I remember the day I quit singing. I was 13 and in a movie theater. My friend and I were watching a movie when a song I knew came on. Given my background, I started singing along. Loudly. And then she said it.

"Don't sing."

I died. Literally, part of me shriveled up for 14 years. I became a very soft-spoken person. I played small. I made myself quiet. It seemed to make me fit in more. But I was always hiding.

Hiding my voice created some seriously limiting beliefs for me in the years that followed. I had a hard time speaking in class, imperative for participation grades in college. I never spoke up in group work, and frequently felt thwarted in projects requiring group collaboration. I also became deathly afraid to talk to men I was interested in. I stuttered and stumbled through social situations, and spent lots of time by myself. I hadn't given up on people or interaction, but I was deeply afraid of rejection.

I was so afraid of rejection that I completed a college degree in something that required I speak little, and write a lot. I was going to be a lawyer. I could defend people's rights, and happily never speak again except in response to questions. Speaking in class gave me the cold sweats, and I was never going to put myself in the position of embarrassing myself again.

Lucky for me, I met a friend in grad school who heard me sing occasionally. I still loved to sing, but I never did it in public. But I did when I gardened. And when I walked on the beach. And when I sat in the car. Frankly, I was singing all the time by the time I was 25, I just didn't realize it yet.

My art had never left me, even though I had temporarily left it. It hadn't gone anywhere, and had finally found a way to quietly surface with my permission. I was the quintessential shower singer. One day, with the encouragement of a friend who noticed how happy I was when I sang, I started taking voice lessons.

It was really hard to get started. Every voice in my head told me to quit, run away, give up and "be practical," whatever that meant. But I showed up every week and practiced, despite making some truly awful noise to begin with.

Fast forward to my first recital, age 27. I had spent three or four months preparing my song. On the way to the auditorium at my local community college, I realized I had only shaved one of my legs. I was so terrified I would forget the words to my song that I wrote them on my hand. I arrived to find I was over-dressed in my long cocktail dress, while others were in pants or casual dresses. In short, I was a wreck.

I don't even remember how I got the name to that first voice teacher, but the minute she opened the door in blonde cornrows, I felt less nervous. Once she demonstrated a high C, I was hooked! Classical singing was cool! People got to be loud—on purpose! And so I studied how to make very, very big sounds using only my breath and body.

On the night of the recital, something awesome took over. I was nervous as hell, but I also knew my song. My inner artist took over. She knew the words, the tempo, and even added a little movement to my performance. My dad even got a shot of me, eyes closed, arms stretched wide, face beaming at the end of my song.

It wasn't perfect. I know that, but I don't care. I gave my first performance, and that was amazing. What happened next was the beginning of a huge transformation.

As I sat down in my seat, the woman in front of me said, not kindly, "She's got a really loud voice."

Part of me wanted to die. And part of me was stoked! Filling a room is a classical singer's dream! I wasn't a wimp! I was nearly a diva! I was shocked. I was elated by her comment. How did this happen, I asked myself?

In one moment, I reframed an entire block into an asset by asking some special questions. It has created a shift I still use today, and so can you. It's important to ask the right questions, though.

First, and foremost, a good question looks for strengths. For example, how can the "flaw" become an asset? What tool is needed here (practice, classes, instruction, better supplies, etc.)? Then, I decide if I want to keep the newfound asset in my creation.

Here are some examples:

Criticism: Your art is too "loose."

Questions: How can "loose" be an asset? Is it one I want to cultivate? Is it fun? DO I like loose art?

Asset: My art is evocative and playful because it works on "feeling."

Criticism: You are always creating your own melody (why I quit classical music).

Questions: When is this trait a strength?

Asset: OMG! I might be a songwriter (yup).

Criticism: You won't be competitive in Hollywood, but I like your spoken word.

Questions: Did I want to be "competitive" in Hollywood? How was my spoken word so different? Was I willing to work hard enough to change in order to become a Hollywood singer?

Asset: Duh, spoken word rules, and competition is for horse racing. Let's do more of that spoken word thing.

Criticism: Your drawings are kinda... scary.

Questions: To whom is it scary? Do I want to make scary art? Does scary have some place in the world, or in my heart? Are there other scary children's books out there, particularly ones I like? (Oh yes, there are...)

Asset: Yes, sometimes they are, it's totally new niche for children's books, don't you think?!

As you may have noted, keeping a sense of humor is important, even when the stakes are high. And I mean high stakes like: I believe art is life and death serious for me. I can't live without creating. It feels hopeless, lonely, sad, and worthless to imagine not doing something to let my creative spirit out. Some days are more prolific than others, but at the very least, I will make myself a nice salad or color something.

Fear and Love

One of the key points to remember when considering blocks, especially when getting started, is that fear and love are on the same continuum. Fear is total non-acceptance. Love is ultimate acceptance.

Consider what that means to the art-making process. And yourself. Can you imagine how you might love doing something so much that you would "feel the fear and do it anyway"? Can you imagine wanting to do something so badly that you thought about it daily for years, but didn't do it? Do you have something that you do only when you are alone, afraid that people will judge you? Or are you putting off something you dearly want to do because you are nervous about how it might turn out (audition, an art class, taking a first lesson)?

This is fear, non-acceptance, running the show. Great! Let's give it a face and a name. I like to think of fear as a black, fuzzy Muppet-esque creature named Fizgig who has bright green eyes and no mouth and who likes to pull the ropes on stage while sending equipment crashing to the ground around the actors as they are trying to perform. (You can picture your own fear monster, but do NOT make it too scary. Give it some charming, exaggerated feature like big hands or large ears, anything that makes it adorkable).

Now, picture your inner artist as a kind, lovely being who just laughs at the fear monster, gently takes its hands off the ropes, and sends him for a cup of coffee. Say, "Thank you, we are going to make some stuff now. You can play later." And send that stinker to get you a caramel macchiato–in Italy!

Distracting your fear monster by lovingly redirecting him to worry about other things is a great way to step around any kind of wall. Your fear might have very real concerns, like *Is that note totally on pitch or am I off,* or it may have not-so-kind accusations rooted in beliefs like *Dude, I suck. I always suck. I even suck at sucking.*

Learning to tell the difference between a helpful question and rhetorical sabotage is to see if it has a solution in the answer.

For example:

I think this color is too dark. Can I add some white?
I think I am off a beat in the second verse. Let's walk through it without music once.
Hmmm, my croissant is too brown. Was it the oven or the formula? Let's try again with mom's oven.
I am not sure my story is flowing to my reader. I'll try reading and acting it out and see what happens.

Do you see how loving questions can quickly guide you onto the right path? Fear-based question almost always leave you feeling hollow, less than, and small. They also rarely have real-world solutions.

Here are some less useful, common fear-based questions, which have no solutions in their answers.

Why do I suck?
Why can't I get this?
Why don't I ever get picked for anything?
Why do I bother?

You get the picture. These questions are not really helping us make anything other than a bad self-image. Good questions lead to insights, progress, growth, healing, and new directions. They also provide possible solutions. The questions above do none of these things. Noticing when your fear is running around asking fear-based questions like these can really help you get unblocked and feel more inspired, courageous, and empowered.

Fear is a great and healthy thing in the wild, but it can run our brains if we let it. Love, however, can quietly take over, and makes a much better ally for creation. Think of something or someone you love greatly. It can be literally anything that makes your chest sing, your body buoyant, and your spirit lift. Feel how it seems to permeate your chest, your heart, your eyes, and your entire being as you focus on the thing you love.

This is the creative sweet spot. There is no push. There is no pull. There is a sense of expansion and fulfillment, despite a lack of action. This is where the muse lives, ideas soar, and creation begins. This is a great spot to start a project from.

Do you have something you want to begin? Something you want to complete? It is all here, available to you in this creative place.

Think of creativity as never ending love for your creation. If you feel stuck, try to imagine something you really, truly love to move you out of the space that's preventing you from moving forward. Focus that feeling towards what you are trying to create.

Casual Magic: Limiting Belief List

Number your page 1 to 10. Answer the following questions:

1. I am afraid of becoming…
2. I am scared that if I start this…
3. I worry that I won't…
4. I am pretty sure I can't…
5. I don't think I…
6. I always wanted to…but never did because…
7. I can't do what I love because…
8. If I make a mess…
9. If it stinks on the first try I will…
10. If I take time to do this… will happen.

Casual Magic: Your Inner Rebellious Teenager

Ah, high school, that time when everything equated with authority was met with challenge and a dose of bad attitude. Well, at least for me it was. Even if you were an angel, let's imagine you were a rebel with a cause and apply some serious rebellious attitude to the above list. So put on some dark sunglasses, a leather jacket, and answer your items in the above list with some irreverent comebacks. It's okay to be snarky, rude or even a little mean here.

> *Example:* I am afraid of becoming a crazy artist and I will never have any money and I will live in a van like my uncle who always smelled like ripe bananas and way too much weed.

Teenager: Whatever, vans are cool and pot's legal now. Duh. And you make money on the Internet now. Cool, so does he live in a tree?

Example: If I make a mess no one will love me because being neat and tidy is important. Plus, who will clean that up later? Me.

Teenager: Um, yeah, I don't really need to make my bed because I have a world to save and we are heading to Starbucks right now. Check out this video in Facebook about the trash gyre. THAT needs cleaning up. Late!

Example: I can't do what I love because I will live in a cardboard box.

Teenager: *#$! ing whatever. Mark Zuck-er-burg.

The point is not to be unkind to your fears, but to see them with the faith of a person who has not yet failed and really doesn't believe they will–a child with an emerging sense of "well, why not?!"

Well, why *not* you?

Casual Magic: Poison as a Cure

The Greek term *pharmakon* means something that can be a remedy or a poison. I find this is true in working with our minds as well. So, let's take a poison (a downside, bad habit, or negative belief), and see how we can use it to help us out instead (a cure) as well as how it applies to art and creativity. The point is to turn your challenge into an asset. Even it's

not your ideal, it can become a wonderful surprise if you take on the mindset that you will make *something* from this so-called poison. I once lived in a small studio apartment where, lacking a space for a large easel, I sat down one night with some Sharpies and a pile of blank scarves from a local craft shop, and fell in love with making my own wearable art. It was born of circumstance, but it turned into a passionate pursuit for quite a while.

Here are some examples:

Poison: Perfectionism

Cure: Attention to detail

How to Apply It: Try doing something that requires massive attention to detail (like quilling, croissant dough, realistic oil painting) and letting your perfectionist create lovely details that stop slackers in their tracks with awe.

Poison: Sloppiness

Cure: Abstract art

How to Apply It: Literally throw down some color on a canvas. Spread it all over. What's it look like? Great, there's your title! You are a genius.

Poison: Teeny, tiny, apartment with no room

Cure: Scale Exercise: Teeny, tiny art

How to Apply It: Create a ballet in a mime box (only three feet wide), re-invent your favorite meals as tasting dishes or petit fours, or turn the entire place into a

tribute to the set of *Out Of Africa* (or substitute your favorite film).

Here's your turn:

List three habits, attitudes, or circumstances you think keep you from working or working at your best:

Now list three ways you can turn those items into assets:

Think of some ways you can apply them:

Check out more lists of poison/cure ideas on my website at www.daniellefournier.com

Chapter 3

AFFIRMATIONS AND (ART)FIRMATIONS

That's the great thing about art. Anybody can do it if you just believe. With practice, you can make great paintings.

—Damien Hirst

A ffirmations do not have to be bland or cheesy like Stuart Smiley of *Saturday Night Live* skit fame, who endlessly chanted "I'm good enough, I'm smart enough, and doggone it–people like me!"

They should feel true to your heart. Not your brain, your heart. So, now that you have looked into some of the lesser beliefs that are holding you back from your art, let's look into some beliefs that CAN serve your desire to produce creative things. Aside from personal beliefs like, "It's my destiny," or "I am meant to do this," all artists don't always have great habits

about reinforcing positive feelings regarding their art. Certainly, looking to the outside world for validation can leave you feeling criticized, insecure, untalented, or possibly even devastated.

I truly believe many emerging artists are stymied by showing off their creations in early stages, seeking feedback. It makes sense, doesn't it, to show our work to a friend, a family member, or a loved one and hopefully expect some praise? (I still text my mom "in progress" shots of my easel.) Hoping someone will honestly sanction our creation, the artist reveals their creation and risks it all. Sometimes it goes well, sometimes not. Sometimes the feedback is so brutal they will quit altogether. (This, by the way, never really says anything about the art so much as it has something to say about the critic.)

The crucial part is to realize that the criticism can stick to us like a magnet in the way of negative self-talk, if we let it. But yet, very few artists want a life where they never share their creations. At the very nature of any art is a yearning to connect, to evocate, to transform—which is generally accomplished by displaying the work.

What's an artist to do, then?

Build your own arsenal of FACTS about art.

If Hemingway told you to write a book, would you listen? Or if Monet showed you a way to paint a lily, would you argue with him? Would you follow Balanchine's direction, Lloyd Wright's instructions, or Whitman's advice?

Probably you would.

Those venerable artists would never tell you to quit, find a "real job," or deprecate art in general, would they?

So, neither will you.

Instead, you will start using affirmations with a capital A for Art. Affirmations are statements–positive and uplifting in general–that are usually short, memorable, and create genuine feeling for the user. Notice I said "user." Affirmations are wonderful, fun, useful tools, but like any tool, they must be used. In this process, though, we will be focusing not solely on personal statements like "I can make art," or "I am a talented and prolific writer," or "I am willing to try…," but also on specific quotes that resonate within our deepest beings from some of the world's most celebrated creative people. After all, they know where it's at, and many had something to say about their loves, work, and creative practices. Who would you rather believe regarding art, Rembrandt or your neighbor who is a banker?

I like to call these resounding quotes Artfirmations because these are both inspirational and affirmational.

Here's are a few examples:

"Life beats down and crushes the soul and art reminds you that you have one." Stella Adler

"One must from time to time attempt things that are beyond one's capacity." Pierre-Auguste Renoir

"Controversy is part of the nature of art and creativity." Yoko Ono

"Sketchbooks should be the one place without rules." Marilyn Patrizio

"The artist is not a different kind of person, but every person is a different kind of artist." Eric Gill

As a practice, I routinely print or calligraphy my favorite Artfirmations like the ones above and tape them to my bedroom

door so I see them every time I leave the room. I never start a day without reading at least one. It sets the tone of the day and gives me strength to remain on course.

Simply Google "art quotes," your favorite artist, or your discipline, and there will be many, many choices to select from. Find something that really stuns you, makes you cry, creates a sense of nobility or righteous indignation, and copy it (this is okay for personal use). Now decide somewhere to put it where you will see it often. A refrigerator, a mirror, a cork board, or your wallet are great choices.

Then, just read it whenever you see it.

It may feel odd as you read the sentence at first, as you are choosing something to embody and become, but you will be surprised how quickly you find yourself anticipating, repeating, and *agreeing* with the words.

If you find yourself arguing, contradicting, or mocking the Artfirmation, that's okay. But don't take it down.

Why not argue the Prayer of Saint Francis with the monk himself as he were alive now? Maybe you have a something to say to that man who never seemed upset. Go for it, and realize that you are arguing with a limiting belief or a wound that can be healed by taking this advice in. Try this as an experiment. Argue with a quote that bugs you on some level. I'll show you an example with the Prayer of Saint Francis:

> Lord, make me an instrument of thy peace.
> Where there is hatred, let me sow love;
> Where there is injury, pardon…

You: "Oh yeah, sure, the nuns hated my drawing, and I should love it anyway? Or them?

Saint Francis: Only in loving others can you love yourself. And yes, you made your art so you are loving yourself, which makes you a servant of peace.

You: Oh. Kind of a "be the love you seek" thing. Sure, fine, but they are still mean.

Saint Francis: Perhaps, but you are not, and you want to be a servant of peace.

You: I suppose… gah!

Really, you don't have to love the passage or quote in one argument, but I suspect you will find you begin to see its wisdom, and you will question what *exactly* bugs you about it.

For example, I love/hate Hemingway's attributed quote, "Write drunk, edit sober." (When I write, I do feel a sort of intoxication, and certainly feel very sober when I came back around for a round of editing.) Every time I see it, I tend to feel slightly irritated but somehow jovial. It's so *irreverent*. It encourages drinking while creating (which I find has a blocking effect on me), but I simultaneously love the "edit sober" part, which appeals to my sense of humor and my belief that creativity comes first, revision second. It's been several years since I first saw it, and I still have mixed feelings. I just let them play out, knowing I have looked at them a little more closely and secretly wondered, *Would that work…?*

Using regular affirmations is an important way of building a new set of positive, supportive thoughts. Thanks to the internet,

there are lovely affirmations everywhere online, many made with great art that's available to print and hang up anywhere you choose. You will most likely find that once you start creating and collecting Artfirmations, you will become a fan of them and hang them everywhere.

Casual Magic: Find an Inspirational Message and Stick It Somewhere, Anywhere

For the beginner: Troll your Facebook feed and print one thing (with words) that stirs you to beauty.

For the Intermediate: Cruise the internet for a theme, a subject, or your favorite artist. Try (artist's name) and quotes. Print your favorite.

Advanced: Take one of your limiting beliefs from chapter 2 and either find its opposite or re-write it so that it is an affirmation.

Example:

Limiting belief: *No one ever pays me for my work.*

Opposite: *I am well paid for what I do.* Or, *Artists are some of the highest paid creators in the world, right, George Clooney?*

Casual Magic: Vision Board

This is one of my personal favorites. Not only are they fun, but they are surprisingly powerful in creating both a map to where you REALLY want to go, as well as serving as a non-verbal cue to your mind. They are essentially wordless affirmations.

Exercise: Find piece of heavy paper or board, whatever size you can keep out where you live. (You want to see this daily, so choose something that won't end up rolled up in a closet because it's in the way.) Using magazines, newspapers, Google images, or catalogs, find as many images that call to you. Just rip, cut, and tear until you feel you are done. Feel free to add some decorated paper, origami, or scrapbook paper that interests you. It's ok if it doesn't make any sense. Just because you like it–it's important!

Now, glue it all down. It doesn't matter what order or arrangement–just whatever feels right. Yes, this is just like making a second grade collage. Keep going. Add images until you are done, out of images, or both. Trust yourself to know when it's enough.

Was it fun? Did any images make you cry? Did any images surprise you?

Casual Magic: Wear Your Affirmation

Tee shirts, jewelry, tattoos–they can all be affirmations. There is an inexplicable power in wearing your thoughts on your body. It's like it seeps in. Or, at the very least, you will get a good run of eight hours if you wear it to work. The great part about this is one is that it can have deep meaning to you, and look like something ordinary to an outsider.

For instance, when I was trying to get over my fear of planes enough to even get on one, I wore a thick blue rubber band that was meant to be snapped every time I started to think really horrid flying disaster thoughts as a behavior modification trigger. I don't remember exactly how many times I actually

snapped it, because it hurt *a lot*, but it became a symbol of bravery for me. Most people probably think I handle stacks of money or something that needs binding, but when I look down, I see a constant reminder that I was once at a point when seeing a plane in the sky could make me cry (and now I have been to 41 countries). It never fails to move me, and there aren't any words involved.

Exercise: Find something that symbolizes your desire as an artist at the moment. Is it a Hobbit-esque ring that reminds you of your imagined protagonist? Is it a blouse that reminds you of a ballerina? A shade of lipstick that dares to speak *chanteuse*? A handbag whose color reminds you of the deepest ocean whose mermaids you like to write about? Alternatively, it could be as bold as a tee shirt that proclaims you "wild" or "free" or "bad to the bone." The closer you get to putting your desires onto your body, the closer they are to becoming part of you.

Check out some of my vision boards and links to other Artfirmation resources at my website www.daniellefournier.com/resources

Chapter 4

STILLNESS

I want to do to you what spring does with the cherry trees.
—Pablo Neruda

Your art wants to work through you. This is most likely to happen when you have some space cleared for it to appear. In this chapter, we will look at some ways to "clear the mechanism."

In the baseball movie, *For Love of the Game,* the pitcher uses the statement "clear the mechanism" to center himself from the countless distractions that could put him off his game when he is about to throw the ball. The crowd is jeering, there is a train passing by, the stadium is loud, but he desperately needs to pitch. It's his job, his love, everything that matters. He says to himself, "Clear the mechanism." Suddenly, everything goes

quiet. It's just him and the ball. He's centered, calm, and in the sweet spot of his gift.

He throws. The ball hits the catcher's mitt with a *thwack!* He cleared the mechanism for his gift and *voila!,* magic happened. The same will happen to you if you learn to clear your own mechanism.

Stillness

In any walk of life, cultivating inner stillness is important because it allows you to hear yourself think. And feel. And dream. And discover your next great project.

Meditation is a great way to spend some time in the company of stillness. There are many styles to choose from, but each entails spending a set amount of time just hanging out with yourself, doing very little or nothing at all.

Sound scary? Well, it might be, if you terrorize yourself with negative thoughts. Most people find that their mind just talks like it's on a double espresso laced with energy drink while speeding on the freeway to work. You might fidget or squirm.

It's all good. Especially once you find a moment or two of what is called "the gap." It's the space between our thoughts, made up of pure stillness. Think of it as the night sky between the stars, if you will.

In that space of pure stillness, insights arise. I can't tell you how many times I have sat down to clear my mind and found a sudden solution to a problem that has plagued me for days. The same is true of when I shower, drive long distance, and take long walks. *Something* shows up for me. And I have to say, more

often than not, that is my muse, and she's always dead on the money with her insight.

The implementation of a meditation practice has a two-part component that has serious power when you decide to follow through with it. First, you set aside time for something you consider important, and second, you show up for that commitment.

That is big-time art practice.

Choosing a Meditation Style

Most people's complaints about "trying" to meditate begin with, "But I don't have an hour, or even a half an hour to spare." Well, don't worry about that! Sitting down and doing it AT ALL is far more important than how long, where, what style, etc. The important thing is to start and see what happens. After all, it should feel good after you do it, and therefore inspire you to more frequent, possible longer sessions.

Whatever style you choose, there will likely be three critical components: body, breath and mind. Let's consider what the goal is for each one in a meditation session.

The body should either be in a formal position meant to create good circulation energy flow, or a comfortable position to promote rest. Choose whatever works best for you, so that you think about your body as gently and as little as possible. Seriously, if you can't sit in a position for 15 minutes, don't do it. You'll be thinking about how uncomfortable you are the entire time, or causing strain or injury. Many people like to sit cross legged on the ground or upright in a chair, as these positions promote alertness with relative comfort. One key in all postures

is to keep the spine straight by gently elongating the torso. You can even lie down, but beware, you will most likely fall asleep, and occasionally very hard, depending on your fatigue level. Make sure you are not hot or cold, or in a noisy place full of interruptions. (I like to sit on my bed, earbuds in, with big pillows for bolsters early in the morning when it's semi-light with a luscious-smelling candle. I mean it–get *comfortable*.)

The second component is the breath. It's vital to our lives, yet most of us never give it long spans of attention. Beware the temptation to take too many big, deep breaths as you begin, as it can cause yawning, dizziness, or a buzzing sensation. One or two big, soft breaths in is a great beginning, but then just settle in for observing whatever is your normal breathing. Somewhat ironically, in trying not to control the breath, it becomes regular, restorative breathing that flushes toxins, expands the often tense muscles of the head, neck, shoulders, and back, and calms the body. Many methods of meditation follow the breath as a means of clearing the mind by creating a focal point for our busy brains. There's really nothing to be done here with the breath but just notice it coming in and out. I suggest considering the breath like the waves of the ocean whose waves wash rhythmically upon the shore. Visit https://youtu.be/qREKP9oijWI for some beach inspiration.

Following the breath can be made into a mantra (a word or sound made to aid in concentration in meditation) by repeating, "breathing in, breathing out," or simply, "in, out." Don't make it too complicated, or you'll spend your time doing nothing but thinking about it. The purpose of any mantra is to

take that mind and give it a simple, repetitive task to focus on while you do other things.

The mind. What a wonderful thing to waste when you meditate! I promise you, your mind will invent every problem under the sun to get you to pick up your phone, grab a pen and paper, let the dog out, let the dog in, go jogging, worry about possible illnesses, or beg you to reply to that email *right now.* Chat, chat, chat. That's its job, it's certain, and it will go non-stop to prove itself a valuable and venerable ally. The trick is in knowing that it's just running a stream of thoughts, and that you can choose if they matter, and when.

If I am having a particularly busy or bad day, my mind seems to never cease telling me what I should be doing instead of meditating. So, I always keep a pen and paper handy (don't use your phone, I promise you will check your email) and write down stuff I repeatedly worry about, like an email I need to send. I will quietly write down a reminder, and return to my study of stillness. If the list seems long, I stop my timer and get my worry list out of my head. Usually that quells it for a time and I begin again. It's impossible to stop your thoughts, but as you quiet down, the quality of the thoughts will improve. The knowledge you possess is available, but you need to be still long enough to hear them.

Walking Meditation

One of the easiest ways to get started meditating is to walk. In our busy world, it's a simple means to get us doing a repetitive motion that disengages the brain while still giving it enough to do. Basically, walking meditation is a hack for getting around

our busy minds, which makes it ideal for beginners and seasoned meditators alike.

Here's how to get started. Go for a walk in silence. I know, you really want to put your earbuds in. (Even with gentle music, this isn't pure stillness. I can't fully explain why, but there is something very different about walking without any added sound and walking with even meditation music.) Set a timer, and set out for 15 minutes to half an hour. Direct a gentle gaze towards your path. I recommend a leisurely, comfortable pace in which your breath comes fully and naturally. As you walk, practice noticing your thoughts without really thinking about them. Kind of like eavesdropping at a café while you are actually really into a good book. *Hmm, interesting…* and return to following your breath as you walk. You can try to walk and chant a mantra (see the resources section at the end of this chapter), but I find it makes me feel busy.

If this method works for you, at the end of your walk, you should feel clearer, quieter, and calmer. If you feel fuzzy, anxious, tired, or upset, this is not the method for you.

Sitting Meditation

Sitting mediation is probably the most common form of meditation. It asks the practitioner to sit while relaxing mind and body for a set period of time.

Predominantly, sitting meditation falls into two categories: Buddhist and everything else. It also has a variety of techniques, from highly regimented to unstructured. See below for a list of common meditation systems and their details. Nowadays, many systems are taught specifically by

a teacher and trademarked or named, and they usually have detailed websites offering loads of information. Meditation has a style for everyone, and I recommend that you try a few different kinds to find your best fit.

As far as the actual sitting goes, that depends on what style you prefer. Some forms instruct on folded knees, some on cushions, some on chairs, some anywhere that is comfortable. As mentioned above, I would just find a way to be as comfortable as you can be for 15-30 minutes as you start out. Clear distractions, including your phone. Close your eyes. And just sit there with whatever form you choose to follow. *Vipassana, Metta, Transcendental* ™, *Angel, Yoga,* and Zen and Primordial Sound (taught by the Chopra Center) are just a few of the modalities you will find available.

There are a few quick ways to find ready-made meditations. Google "meditations." Add a time limit if you want to narrow your search, like "short," "quick," "15 minute," or specialty categories like "morning," "evening," "calming," etc. Go to YouTube and search for "meditations." Many videos there include nice visual scenery as well. Podcasts, CDs, and books are also widely available.

Guided meditations are recordings in which an author has set an intention on a specific topic and uses music, words, and possibly a bell or chime to focus the meditation for the user (you). It could be a prosperity meditation, a sleep meditation, a releasing meditation, or a clarity meditation. I have recorded a meditation specifically for this book called *Love in Creation* that's available free at my website if you want to get started today. Check it out at www.daniellefournier.com/meditations

Casual Magic: Try Three Kinds of Meditations

Google or search your apps for three meditations. Start with guided, if that's easiest, or simply try sitting for a while. What happens? Can you commit to five minutes a day to start for a week? Do you feel, calmer, gentler, more focused?

Casual Magic: Sleeping Meditation (Seriously!)

Ahhh, these people know what I like. You lie down, you get comfortable and still…and pretty much fall asleep. And what a wonderful sleep it is! Eventually, you will probably stop falling asleep in this ten-minute guided meditation, but so what if you don't? It's incredibly relaxing, easy to do, and you can totally do it before going to bed, which counts!

Google "Yoga Nidra" and try one of the recorded sessions. Follow the instructions and check in with how you feel afterwards.

Casual Magic: Planned Daydreaming

Here's an odd kind of affirmation-meets-meditation method that rocks.

Set a timer for three minutes. Now pick a fantasy related to your art. Are you a rock star? Are you at your gallery? Your premiere at the Met? Are you telling your family you just got a book deal?

GO BIG. Feel it. Now live every lavish detail for three minutes or longer. What are you wearing? What's your hair look like? Who's with you, if anyone? What color is your nail polish? What's it smell like, taste like, feel like? Make it real.

Do this at least once a day (please not while you are driving), every day. Forever.

How did it feel? Is there any way you can add one element from your fantasy to your life today–the lipstick, the nail color, a new haircut, sign up for lessons with your dream teacher who you dedicated your Oscar/Tony/Emmy acceptance speech to?

Visit my website and share your fantasy with me! I'd love to hear it. It's probably not as crazy as you think (why not ride a dragon with R.R. Martin discussing plot devices?!). www.daniellefournier.com/fantasywall

Chapter 5

OTHER PEOPLE'S ART AS INSPIRATION

The capacity for delight is the gift of paying attention.
—Julia Margaret Cameron

Screwing Off Is Good for You

And it is good, no, great for your inner artist. Time spent without responsibility, pressure, structure, or consequences is just what you need to get great work out into the world.

I am all about meaning, but heaven help me if I don't love a good skeeball session just as much. I also regularly indulge in cartoon bingeing, doing voices for my dogs, doodling horns on people in magazines, and watching

whatever new gearhead video my little brother has sent me on Facebook.

It wasn't always this way. For nearly seven years, I hardly goofed off if I wasn't at work. (I worked with my family at the time in retail and they are a load of hams who routinely wear anything silly as headwear, just because it's hilarious.) I didn't have a TV, and I rarely did something that didn't directly "support my art," like go to movies or read popular novels or attend concerts.

I was convinced that if I wasn't making my art a reality, I certainly shouldn't consume anyone else's. (This theory did not apply to recorded music, for some reason.) So I ground my way through a Masters of Fine Art in Creative Writing while travelling 28 weeks a year away from home and working 10- to 12-hour days six days a week. Needless to say, I was very intense, and frankly, not a lot of fun. Which didn't bother me at the time because *I was dedicated to my art.*

Then something kinda cool happened. I ended up living at my mom's house in California. She loves TV, and has a huge one with every channel you could ever want to watch, including something called Amazon. Which is where I discovered *Game Of Thrones.*

OMG! TV for geeks?! A whole week went by in pajamas (I worked at home at this point) as I plowed through season after season. Then I found *Mr. Selfridge, Downton Abbey, Outlander, Orange Is the New Black,* and a whole mess of stuff I had been missing.

I was in! These were my people! Talented writers with imaginations and sets to die for and eyes trained for historical

detail. I was in heaven. I couldn't believe I had given up consuming, well, mostly visual art of the filmed variety.

And then it struck me why. I was sad. I wanted to be them so badly, I couldn't watch other people's dreams take flight. Especially since I wasn't really getting anywhere with the novels I was writing at the time. This was the same reason I never watched the Grammys, but could watch the Oscars. Again, I was a creator, just like these people. Inside I was dying, though.

Watching all that TV got my blood boiling in very fine way. I was excited and the next time I went to my easel, a winged dragon appeared when I was trying to draw a horse. And a new children's book was born!

Hmm, there must be something to this whole consuming other people's art, I thought. I wasn't critiquing their work, or analyzing plot structures, mid-points, and character arcs, as I had been when I watched anything in school (I did a film script as a thesis), I was simply having fun like I hadn't since high school. It made my art better, pure and simple. So I slowly added more and more slacking, dinking off, and creative indulgence into my daily routine. And believe me, after so many years without a TV, there was a lot of stuff to learn about. And totally love.

Somehow I started adding more and more activities into the *fun* category, which was becoming a requirement. It seemed like the harder I worked in my studio, the more I felt I could go blow some time doing *whatever I felt like*. A certified introvert, I started accepting invitations to parties, concerts, polo matches—you name it. I met more people and created a social life.

Oddly enough, all this outward activity fed my internal landscapes. I chose different subjects to paint, I had different

angles on characters from spending more time with varied people, and my working hours became much more deeply focused. It was a win-win situation I never saw coming.

Creating a Feast for Your Brain

It is a bona fide myth that creative people need to work a regular eight hours straight and not take a break. It's a very intense process that requires regular breaks, relief from the intensity, and replenishment for the soul. Even if you consider yourself a focused worker, I'll venture that you will benefit from stepping back now and again. Chris Baty, creator of National Novel Writing Month (NaNoWriMo), calls the breaks he and his organization created "Procrastination Station." They were designed to give writers creating a novel in 30 days something to do with their brains when they were suffering fatigue, frustration, boredom, and procrastination. Usually silly, poetic, beautiful, or random in nature, the NaNoWriMo web page had a list of ways to screw off. Having done NaNoWriMo three times, I can tell you, it works! So I adopted the practice in my studio. Every time I get to a stopping or pausing point, say to let something dry, or to change colors or canvases, I do something fun for 10 to 15 minutes. It can be throwing the ball for the dog, eating something awesome, picking flowers, Googling small villages that feature cooking schools in France, pinning Dragon Art on Pinterest, or simply sitting outside and watching the wind blow in the trees.

This habit will most likely spill over into your evenings as well. When was the last time you went to a movie the night

it opened? Or rushed to a bookstore to buy a book on its release date?

It's important to feed your inner artist's imagination as well as share it. How else will it come up with new ideas? Your artist brain needs to dream, to languish in ideas, textures, and colors. Consuming others' art is not only inspirational, but it can be informational and transformational as well. Some scene played out in a book, in a film, or on a stage can cast the way you see whatever you are working on in a whole new light. It can also inspire you to a whole new idea, just because you loved the way "they lit that shade of red" in the third act.

Consuming other people's art will not only feed your soul, it will do something magical to your practice. It will become your practice as well. Whatever or whoever you consume will integrate into your body of knowledge. They will teach you their art by simply being exposed to it. Rather than simply "stealing" or "adopting" someone's style, you can learn small acts that will send you in new directions, if you choose to follow them.

Reading is not time wasting. Reading is a lovely way to do more than nothing, it's a way to do create something from nothing using your imagination. Words may be lone characters on the page, but they are fraught with meaning. We conjure the author's expectation into reality with our own personal brand of consciousness when we read. It a version of interpretive art, this kind of daydreaming. Choose books that transport you to other realms, worlds, places, beauties, and sensibilities so your imagination can engage. Reading engages the mental play, creating fireworks of inspiration and dazzling displays of adventure for the soul.

Watching anything can be done with mindless enthusiasm or with careful purpose. Both create results, but in very different ways. The gleeful consumption of sensuous visual images can be transportive as well as mesmerizing. This kind of consumption is visceral and tends to elicit a body centered, emotional response to which the second type of consuming can be applied. Careful, purposeful watching is geekdom at its best. We are not talking film school critique here, we are talking fandom. Consumption on the eat-it-with-your-hands level of enthusiasm. The first time I saw the Federico Fellini film *La Dolce Vita*, I fell in love with Rome, with grit and grim love, and with the lives of the people who I was certain were only pretending to act on the screen while they were secretly the director's real life acquaintances who had permitted him to film their lives. Seeing Anita Ekberg in the fountain, drunk with wine and life, making a spectacular scene, I was fraught with questions. *How did they make that? Why was it so taught and universally acclaimed? What made it so special? How can I make that?*

Another fantastic way to watch art is via the internet. From museums online like The National Gallery in London to the Smithsonian and the Louvre, many museums have partial or full collections online (including a link to the Sistine Chapel from the Vatican Museums). The Google Art Project, an online repository of tens of thousands of works all over the globe is another place to go diving for all types of art, including music, sculpture, and landscape, as well as painting. Try searching your favorite era, style, city, or artist to see if you can wallow in it virtually. It's great way to view collections without ever leaving home. Or it's a fun way to begin planning a pilgrimage.

http://www.nationalgallery.org.uk/visiting/virtualtour/#/central-hall/
http://americanart.si.edu/exhibitions/online/
http://www.louvre.fr/en/visites-en-ligne
http://mv.vatican.va/3_EN/pages/CSN/CSN_Main.html
https://www.google.com/culturalinstitute/beta/partner?hl=en

Casual Magic: The Artist Date

This is from Julia Cameron's fantastic book, *The Artist's Way*, which I highly recommend. It's a divine 12-week self-study course devoted to recovering your artistic self. This is one of her core exercises.

Here's the gist: pick one outing a week, solo, that thrills your inner artist. It can be silly, dreamy, sweet, childish, daring, HUGE or simply surreal. The point is to honor your artist's needs by making, and keeping, a date with yourself. No one else gets to join. And you really, really should keep that promise to yourself. It's a commitment to your artist. Every living being deserves to give themselves true space to honor their authentic desires.

So pick an hour that no one, I mean no one, can steal from you. It can be less, but one hour of total self-care can undo hours of stress, frustration, longing, and everything else that drains you all week long. It's long enough to dive into your date, but short enough that it can be justified by even the busiest of people. Feel free to write off one of your gym dates because this is relaxation, which falls into the health category, and therefore is just as important as an hour on the hamster

wheel. (Consider this: if you're less stressed, maybe you could skip a latte or two– and that's the caloric equivalent of skipping an hour on the treadmill.)

I promise you that you will invent all manner of reasons to not do this, and I totally get it. It's just a little fear masquerading as procrastination. *What if I actually love it?*, you think.

Ah. You might. You might have grandiose dreams of acts of courage like leaving your job, or some people, or some activities behind for far more fulfilling activities. Maybe you'll skip the wine bar for a dance class next week, or maybe you'll go for a walk with a notebook instead of surf the internet after dinner, or maybe you'll decide it's time to paint the wall you really hate in your home. Perhaps you won't. Perhaps you will just add more fun to your week in an entirely new way.

But you will never know until you try.

Here are some Artist's Date ideas I have tried to get you inspired:

Some were small, some were big, some were free, some were not. The thrill was the point.

- A foreign movie at a theatre
- Indian food for one with a book
- A trip to the zoo with a camera
- A surf lesson
- Fishing with bacon (or marshmallows), string, and a stick
- Fly a kite
- Paint an old chair
- Buy a gorgeous new plant and pot/plant it

- Learn boat repair with fiberglass
- Make raspberry jam
- Watch a ballet set to Sarah McLachlan's music
- Go window shopping somewhere really lavish
- Make a sandcastle
- Put together a pirate outfit at a discount store; wear it *somewhere*

The sky is the limit. If you can dream it, it's an Artist's Date. If you are not used to doing things alone, feel free to tell people you are an artist and that you are doing research for a new project. Trust me, most will be interested in your story and ease any weirdness they feel towards your solo adventures.

Casual Magic: If You Wrote Highlander, It Would Have Had A Dragon

Rewrite, re-arrange, or re-enact your favorite piece of art—as it should have been! *Swan Lake* on horseback, Beethoven's Ninth Symphony as Gamelan Punk, or Mona Lisa Actually Smiles, these are all possible re-imaginings of great art that didn't get made. Well, you get to make it! If you desire, set a 30-minute time limit for the new production. (I once saw a speed version of *The Merchant of Venice* at The Edinburgh Fringe Festival that had the audience rolling in laughter and made for sold-out performances for the troupe.) The key here is to have fun while spending a little time with the piece as an act of interpretation. Your ideas are just as valid as Tchaikovsky's, Beethoven's, or da Vinci's. That hardly means you have to stick with public

domain works. Rewrite a *Family Guy* episode using the cast of *Big Bang Theory* if you like.

Post your art redux at my website www.daniellefournier.com/redux

Casual Magic: Buy a Book by Its Cover

There's some magic that happen when you let something pick you instead of doing it the other way around. Go to a bookstore. See what calls you. Walk along the aisle letting your fingers trail over the spines. Stop at the one that seems to pull at you. Pick it up. Open the pages. Read what's there. Does it apply? Strike you? Inspire you?

Keep doing this until your artist feels happy and full or until you can't leave a book behind at the store. There's something you need on those pages. Let it call out to you.

Chapter 6

BECOME A DISCIPLE
OF SOMEONE GREAT

It's not where you take things from—it's where you take them to.

—Jean-Luc Godard

I love Claude Monet. He's a dreamy poet of a painter who found it satisfying to repeat the same subject of his work many times. I find him so enchanting that I even went to his home in Rouen, France when it was offered as a day trip from Paris. It was there that I found that I wanted to study Monet. Not formally, as in learning all the names and dates of his pieces, but artistically, by asking the man's work *how* it was made. *Why* was it made? How did he put down the paint; by knife, by brush? How far away was he? What colors did he mix? Were they well mixed

into new hues, or left as separate tones swirled together to create shadows?

The questions came from two different experiences that caught me off guard. I specifically went to Paris to go to the Louvre. I thought it was the be-all, end-all of art (and it pretty much is). However, it is also crowded, enormous, and mystifyingly complex. It serves to house, preserve, and curate the world's important collections. But it's also like swimming upstream all day. Large crowds can make contemplation difficult, and lingering up close can be discouraged by docent and attendees alike. I had planned on spending several days there, but saw an advertisement for the D'Orsay Museum that housed the Impressionists and that was also closer to my hotel.

The D'Orsay building alone is a shrine to Beaux Arts architecture, a creamy dome of chandeliers and frescos, but it also contains a definitive collection of Impressionist art. Personally, I love the Impressionists for their love of bucking the French Salon art system while simultaneously creating a new movement based entirely on feeling. It literally turned painting on its ear (sorry, Van Gogh).

While I was wandering the museum, already charmed by the gentle, loose nature of the work presented, I came to Monet's *Blue Water Lilies*. There is absolutely no way to reproduce the brush stroke, texture, or smell of a painting, nor the tiny cracks of the paint as it ages over centuries. Impressionist art was meant to be seen from afar and evoke a feeling, hence the name Impressionism. Instead of painting religious scenes or commissions of nobility, the rogue Impressionists painted the everyday life of man, the country, the seaside, and flowers.

They even, heaven forbid, painted can-can girls. It was widely criticized for being unruly, undisciplined, soft, maudlin, or even "common" by the art elite of the early 20th century.

To me, it was a song on canvas. I had enjoyed Monet's work before on postcards, calendars, etc., but frankly, I thought it was too girly and fussy. I loved the fierce Northwest coast art of my Seattle home, the bright and scary creatures told in myth and legend brought to life on paper with bold colors and striking black lines. My home frequently scared visitors with bared wolf teeth, diving ravens, forest spirits, and prints of lumbering bears.

This was greatly reflected in my own art, as well. I tended to dichotomous prints, black and white photography, little abstraction, and a direct use of color (like, no mixing–ever). That changed when I walked across the bridge at Monet's home in Rouen. I was inside the painting. I saw how he represented that blue, and why he chose it. Because the color really was there at a certain time of day. I could see how the pond presented a new and startling image with each step on the path around the house.

Yes, I thought. *I, too, would paint this scene a thousand times.*

It wasn't like I dropped all my technique and became a different painter overnight. But I became a better painter. I tried new things like different brushes to create different shapes, or walking across the room to see how the canvas looked from afar. I tried blending and making murky colors on purpose. I decided to "quit early," and leave paintings wanting a little instead of worrying myself over one rock in a landscape whose "redux" eventually led to an "overdone" image. I have now

painted in black, which some contemporaries insist does not exist in real life (ultramarine, viridian, alizarin crimson, etc. should supposedly be used for shadow).

Seeing the *Lilies* in real life made me hunger for more museums. What else might I find? Who else could I learn from? Sometimes I felt like I was not a real painter because I did not painstakingly reproduce a scene in perfect color with a brush of only three hairs over a period of twenty years, like I was supposed to be doing as a suffering artiste. Instead, I was a having a ball breaking the rules. I liked to switch colors for others, making sunset scenes out of midday or painting turtles in pink sand. I felt happy to paint bright colors while living in the Pacific Northwest, Land of 1000 Greys. People liked my early work, but complained they couldn't put it on a beige wall. For sure, I wasn't sure I was "doing it right."

After I met the Fauvists, the Colorists, and the Expressionists, I decided that the most important element of my painting was something evocative. A great color, an interesting line, a disturbing shadow. *What was I trying to say?* I learned that from Monet's garden.

You too, can become a disciple of someone great. And it can even be several someones, or a someone for a short season. Say you love someone's art because they use red like no one else does. You love that. How can you add that into your work? So what if it looks like you copied Monet the first couple times? Or even a hundred? You could not be Monet if you tried, not because you don't have the talent, but because you can't live inside his brain. But you can try, and that can be all kinds of fun.

So don't worry if you feel like you are stealing, borrowing, or influenced by great work. As long as you are not actually using their work in your work and claiming it as your own, it's all good. Think of it like this: does listening to great music make you want to dance? Does seeing a great film make you want to rush out and make something, anything? Are you inspired? Wouldn't a great teacher want you to be inspired? Rest easy knowing that the great artists all wanted to teach you, or they wouldn't have made that art in the first place.

There are easy ways to stalk your favorite artist in this day of online activities. (Hopefully, they are not alive or this gets tricky. Like go-to-jail, restraining-order kind of tricky. Don't do it. Concrete cellblock makes for crummy canvas and the acoustics stink.) For example, one of my favorite living artists is Robert Wyland, a California ocean-life painter. Luckily, he has not only numerous galleries, but a public television instructional painting series that airs weekly where *he shows you how he does it*.

He gives you his secrets, shows how he blends the colors, what brush to choose, etc., etc. No art school, no expensive classes, no "repertoire" exercises meant to kill you with boredom, but live, friendly tutelage. In addition, he has Twitter, Instagram, and Facebook accounts where he actually talks to his fans. This is insanely cool because a) he is alive and that's a mega-bonus regarding the information sharing connection. and b) you can do it for free from your couch.

If you are old school, you can head to your library and languish in the collection of art books. One of the items libraries the world over contain is large amounts of reference on art history. If you don't have anyone on mind, you can

cruise the stacks and pull volumes that catch your eye. It's no-commitment, high-enchantment kind of work. Likewise, you can browse your local bookstore for coffee table and collector books for inspiration. Many museums publish their collections into large, bound volumes that are readily available for purchase or on loan from libraries.

The point of becoming a disciple is to fall in love with someone's message and take that message out onto the world. Find a hero, study them, take what wonderful thing they have to offer, mix it with your own love, and carry it forward. You never even have to step inside an art school to learn to be great. Just devoted to a cause that moves you to beauty.

Have you ever considered what it is like to be inside the mind of a famous artist? Not famous at the time, but famous later because they made amazing work, like da Vinci or Michelangelo. Certainly, they had a degree of success while living or they wouldn't have had patrons, but think about what their daily practices were like. What was he thinking as he rose each day, with a huge expanse of cathedral before him? Was he nervous? Was he scared of what people might think? Actually, he was frustrated that Pope Julius made him leave his sculpting of the tomb he was working on to painting the Sistine Chapel ceiling. It wasn't what he wanted to do, nor did he think it was particularly great. But he did do it, for four long years. It became one of the world's greatest treasures.

Does that surprise you? That he did it for dedication and employment reasons? That he even delivered something outstanding because of work ethic, not necessarily inspiration? It's a huge myth that working artists are lucky, or just so

talented they can't help but succeed. The truth is, they succeed because they don't quit. Because being an artist is who they are. Because they just kept on keeping on. (The opposite is also true. Sometimes famous people quit and produce nothing after an amazing success, like Axl Rose's "forthcoming album" that hasn't materialized in 12 years now.) Consider this when you admire someone's work: what did they have to do to get it seen? Was it hard? Slow? Frustrating? Did people try to hold them back? You can look to your hero for their success story.

Why not let it become your own?

Casual Magic: Become Like Your Teacher

This is a pretty straightforward exercise, but your answers may surprise you. List five attributes, habits, or qualities of your favorite artist. How could you adopt some, or all, of them? Would you set up your studio like theirs? Would you adopt their practice schedule? Would you try using their techniques, color palette, or method? Or, would it be something like a tribute: wearing a hat every time you worked, or hanging their picture in your work space, or even using one of their favorite materials?

Casual Magic: Recreate Your Hero's Masterwork as Your Five-Year-Old Self

Ahem, let's get serious about being silly here. Take off the pressure and free your inner artist child. No boundaries, no rules, no expectations. Treat whatever you decide to make with the tender loving care you would treat a five-year-old who brought you their art. No judging, no grown-up, thoughtful

critique. Just do it for fun. Make your homage to your teacher with gusto, abandon, and joy. Make *Blue Water Lilies* in pink. *Swan Lake* as choreographed and sung by you, the prima ballerina. Film *Breathless* on your iPhone using your dog. Odds are, you will learn something about the process of the greats, spend a moment in their shoes, and that's a fantastic lesson you can use over and over again.

Casual Magic: Carry the Book Everywhere

Find a talisman of your hero. It could be a book, a picture, a piece of ribbon that looks like their costume, a feather, a notebook you think they would like– whatever you like. Carry it with you as a reminder of them and their work. Do any coincidences pop up after you start carrying the object? Do you see their work differently as you focus more upon it? Do you feel differently knowing you are now one of their pupils?

Check out some tribute art (and post some of your own) on my website at http://www.daniellefournier.com/resources

Chapter 7

CHOOSING MATERIALS AS A BLOCK BREAKER

I simply do not distinguish between work and play.
—Mary Oliver

Art Is Fun... Isn't It?

Sometimes in the pursuit of your dream, you may forget that you are doing this because you love it. And like any relationship, it can be bumpy, frustrating and confusing. Truly, though, it should feel worth the struggle that sometimes arises. When it doesn't, it's time to take a step back and take your foot off the gas. Wait. Screw off. Distract yourself. And make a nice big mess.

Art, in any form, will embody some of your energy that you used to create it. You might want something intentionally dark, scary, or unnerving. That's not the same as making something half-heartedly. If you are trying to evoke a feeling of fun and joy, starting out feeling frustrated or scared will make it tougher to do so. Whatever you are feeling when you make a piece will tend to fill the form with that emotion. Tentative hands create tentative pieces, which seem to just lack... something. Your audience, 100%, will be able to tell if you try to pull off a half-hearted piece. So will you. So, let's look at some ways to start creating from a place of centered inspiration, no matter what mood you are trying to convey in your piece.

Straightforward: blocks–including disinterest–arise when there's pressure to make something happen. Perhaps you have a great direction in mind, possibly a looming deadline. Only you can't start, stop, or continue. Starting feels like staring into the abyss. Stopping work on even a bad idea feels like quitting, and continuing on a difficult path feels like torture. It's time to stop what you are doing and return to the basics: materials.

There is nothing like a big, beautiful, empty canvas to stir the soul. Or a lovely presidium with blank flats. Or a shiny Martin guitar waiting to be strummed. A pile of pastels in your favorite colors. Mounds of wet clay. Reams of creamy, thick paper. Yards of red silk. The sound of rain. Raw materials are the foundation of most art forms.

Make a Big, Lovely Mess

One of the best pieces of advices I ever got was from California artist Robert Burridge. As a warm-up, he recommended just

picking one favorite color or medium and *playing* with it. No pressure. No rules. No intention other than to be in love with what is in front of you. It doesn't have to become anything. It just has to be beautiful. Chances are, though, it might become something.

Have you ever made something by accident because you were just having fun?

Buy Something, Anything that Makes You Smile

When the inner artist is frustrated, it needs to express itself unconditionally. Sometimes work on a specific project can have too much structure, too much focus, too much direction. Likewise, the lack of expression also makes for what I call "creative bulges": sly acts of creation, indeliberate in nature, that create havoc or detours and that often have detrimental outcomes caused by a terribly bored or frustrated imagination. Plainly spoken, you make a mess in your own life instead of on paper. Bad dates, social drama, financial concerns real or imagined, that awesome imagination of yours is working overtime on *anything* but art.

The cure for this is immediate action. If you are blocked, doing intentional screwing off is always a good idea, and if you are not, it will be even more inspiring. Go to your favorite craft, fabric, supply, or paint store. Wander without hurry. Let your senses take over. Feel the texture of thick paper. Smell the fresh wood. Look at different departments than you usually haunt. Pick up sculpture blades. Take a look at FIMO blocks. Why not consider printmaking? Or knitting? Look for something fun. Cheap is even better, because you will feel no guilt whatsoever

if you only do it once. Perhaps it's time to make that Barbie mold into a cake? Or turn Barbie into a sugared armature for your character study. Choose something that makes you smile.

Starting with play is important. It lets your artist feel safe and unpressured. When was the last time you did something fun for fun's sake alone? Especially in the midst of hard work, it's time to relax and dive in. Here's the paradox of creative living: it feels so deadly serious that the only remedy is to have fun doing it. Playing is serious business, also. It releases the heart to be fully present. And I guarantee you, your "work" will be better for it.

It's okay if you think your work has to involve suffering, sweat, blood, and tears. But is that true? Would you want a child to suffer because she likes to draw? Must you always do your chores before getting to play in the sand? Will making the bed bring you as much happiness as making a dream come to life?

Sure, we all need to pay bills but nowhere, *nowhere* does it say that we have to suffer to do it. It's hogwash, and frankly, bad for your artist. Author Martha Beck has a concept she calls "deep play," which is when you are using your gifts to take you to your best life. It's a win-win for everyone in your life. You are happy and you give that happiness to everyone in your world. That begins with opening up to the possibility that you are meant for and destined to live a creative life. It may not ever be your paying job, that's up to you, but it's your heart's job. First you must give yourself permission to take the pressure off by allowing yourself to create in any and all manner, and that includes an *artist recess* if need be.

Do Something New This Week

Even the most disciplined and steady of practitioners needs an infusion of variety. There is a method of psychology called Human Needs taught by acclaimed personal development icon Tony Robbins that I think explains our supposedly conflicted needs very well. There are five human needs that dominate a person's life on a deep, subconscious level. They are the need for Security, Variety, Significance, Connection, Growth, and Contribution. Security makes us want the same thing. Variety makes us crave options and contrasts. Significance wants us to be special and singular. Connection drives us to social and personal relationships. Growth drives us to learn, adapt, strive and change. Contribution fills us with the need to give what we have acquired in our quest for knowledge, love, acceptance, wealth, or wisdom to others. Many people's lives may seem like a teeter-totter of conflict, because THEY ARE! Every person has different degrees of desire for each need, which is why some people need the security of a pension, and others can't tolerate anything but the daring required to be an entrepreneur. (Growth and Contribution are desired most when the other three needs feel balanced.)

Artists seem to have a greater need for variety and growth than the average population. We are curious creatures, fascinated by the world around us. We want to test unknown waters, stretch our ways of knowing, and explore our options–possibly all at the same time! We can also be stubborn, ritualistic, and superstitious about scaring away the muse by moving anything out of its usual place. Therefore, we can be timid about venturing from what we know into unknown, unproven realms. Creativity

is expansive in nature, though, and its growth inevitable. You might as well give that expansion a direction in which to head by opening the door to exploration on its behalf.

Wear the Black Tutu

Start by changing up something that doesn't work, or is the opposite of how you think you "should" work. If you are always painting in bright colors, try limiting your palette to three, two, or even one color and white. What happens? If it feels good, do more of it. If it stinks, drop it. Did you learn anything? Even if it is just not for you?

For the longest time, I did not paint with black in oil, as I mentioned in chapter 6. For one reason, a mentor told me not to because it didn't represent real shadows. I also chose to adopt the practice because I really hated using black. It felt so heavy. It pulled me down and felt hard to work with, as it really doesn't blend well with anything but white, in my opinion. It quickly drug any bright color into a depressing hue, not acceptable for my chosen subjects of animals and landscapes. Then, one day, I realized I really wanted to do a portrait of a human being. And I love sketching with black pens. *What if I combined them…?*

The results were startling. It was a totally different style! I spent hours using a dark palette to create a Goya-esque portrait of a dancer. I loved doing it. It was rich, and deep, and it released a side of my work I didn't know was there. I had a dark side. I specialize in painting colorful birds, sea life, and sunset paradise landscapes, but this … this was alluring. It started two whole new series that I realized expressed some unresolved grief that

had finally made its way to the surface. It was beautiful. And I never saw it coming.

That's what exploration can do for you. It will not only undo some tension, it can lead you onto a path that is ultimately very fulfilling. The trick is to pay attention to how you feel about what you are doing. If it doesn't fit, it doesn't fit. If it does fit, wear it for until you get tired of it.

Your artist craves the permission to wonder and to wander. It is no great risk to you to let your artist wander. You are safe. Your creative soul will keep you on track, so long as you feed it lovingly with joyous experiences and gentle encouragement. You do not need to quit your job, move to Italy (ok, well, maybe!), or change your life. You only need to put your artist first, because that inner artist is running the show—any and every day.

It's time to give it a clear, open channel to do something terrific in your life.

Casual Magic: Make a Dream Supply List

Simply list 50 things your artist would buy if your favorite aunt gave you a blank birthday check and told you to go for it. Any surprises? Any recurring themes? Anything you can go get this week? Buy one.

Casual Magic: Black Tutu

List 10 qualities that describe you as an artist. Now list their opposites next to them. Are any of the opposites secretly appealing? Circle up to three daring ones you can pull off

without guilt or bodily harm. Implement one. Don't tell anyone what you are up to. It's your secret. Shhh.

Casual Magic: Raw Material Adventure

Let it out. Let your gorgeous, wild, messy, inner artist child out and take her on a shopping adventure. Where does she want to go? Fabric district? Flower store? Book warehouse? Paint shop? Make a date and a budget to go find the coolest thing ever! It does not have to be expensive (only dear), impressive (only to your imagination), or expected (but totally perfect). What does it inspire you to do? Is it a whole of something or a part? Does it need friends? Can you share it? Is it a series? A tribute? A precursor? A symbol? Give it a name.

Check out some links to the best stores out there on my webpage at www.daniellefournier.com/resources. You don't even have to leave the house!

Chapter 8

BAD ART

Read, read, read. Read everything—trash, classics, good and bad, and see how they do it. Just like a carpenter who works as an apprentice and studies the master. Read! You'll absorb it. Then write. If it's good, you'll find out. If it's not, throw it out of the window.

—William Faulkner

Yay! It Sucks!

You are inspired. You are excited. You have a plan. You have the vision. You put heart and soul into your creation. You try your very best, but... your art sucks.

It feels like a big deal. It feels like a really big deal. It might even feel like the end of your world. You will fill your head will all types of unkind words and thoughts. Thoughts like, "I am no good." "I should quit." "I will never get this." Or my personal favorite, "Argh! My mother/brother/school counselor and the dude at the gas station are right: I am just chasing rainbows and had better get a real job and a husband before my eggs dry up." *Blah, blah, blah,* on it goes. You know the drill.

Let me ask you this, when do you know you have failed? What is failure? Bad art is not a failure, ever. It's a lesson. Let me explain why.

If you, as a creative person, have made something today, this week, this month, you have succeeded in your life's mission. Period. Do you think Rembrandt ever threw something out that wasn't up to his standards? Of course he did (he probably painted over it considering the price of canvas in his day). When we quit pursuing our vision, ignore our true natures, or condemn those pursuing the lives we covet, that is when we fail as artists. Simply making one item, or even a series of items, that are not up to par, not what we wanted, or simply didn't work in some way does not mean you, nor your work, have failed.

It has become very popular today to judge, rate, and condemn other people's efforts as if we were the sole authority on whether or not their vision was viable. Televised singing, dancing, and talent competitions are a perfect example of this. We watch and decide if it was good or bad, deliver a verdict in terms of a score, and the contestant either continues their artistic journey or not, depending on the audience's interpretation of their work. We

tend to accept that the artist is not "good enough" based on that one moment in time. There are many times when something doesn't work for an artist, which can have varying results. Sometimes it spins you off in a different direction. Sometimes it creates a fervor to make the vision happen; the artist is resolute in their commitment to make the art happen, even if it takes multiple versions of itself. Don't let snarky people, even your inner critic, ever talk you into thinking any attempt is a failure.

Learning from every piece you undertake is imperative. If you don't like something, it is more beneficial to ask why it does not work for what you intended than simply decry its faults. Where did it go wrong–at the beginning, the end, or in the middle? Did you keep going when the little voice in your head said, "It's good, quit now"? Did you make a good drawing to start with under a painting? Did you have a clear vision? Were you distracted? Did you need a different tool than the one you used? Some subjects are hard to master, and you should never expect to make a masterpiece on the first run.

Personally, I am not great at painting humans, although I am known for my animal work. I can even get a lovely eye on birds, which is tough. When people ask me to do human/animal combinations, I usually refuse because I want to deliver my best. I am the first to say I am not great at people, but I will never say I am a bad artist because of it. Nor because I don't do perfect replicas in realistic oil, a trait that popular culture admires as being a "good" artist. I simply do what interests me and gets me fired up to cover a blank space in color. I love detail work, but I don't like realistic work all that much, partly because I was a photographer for years and find photo work so

endearing. Painting, to me, gives flexibility for interpretation. That does not mean, however, that I don't love and appreciate a great oil portrait, especially of animals where the artist uses tiny brushes to re-create the coat of hair. It also does not mean that I think they are better than me. Judgment, in general, is the enemy of good art making. Whereas good critique explores the process and impact of a work, judgment renders its value, and that quickly create a state of mind that can paralyze a creator.

No one, I repeat, no one, makes perfect art every time. They do not sell every painting they make, nor do they never regret artistic choices in their process. What is likely, with the most learned artists, is that they stop early on in mistakes. They also know to be patient and correct whatever is going on, if possible. When something really doesn't work, they ask the pertinent questions of *why not, how did I get here,* and *how can I change it to what I want it to be?*

Here are a few ways that mistakes, errors, detours, wrong turns, and "hmm, don't know if I like it" pieces can turn around. It can become a series, the first of your birds that look like chairs (this is actually how I started my Rock and Roll Birds Series, I screwed up a crow's plumage and decided to turn him into Steven Tyler). It became a "happy accident," as television painting instructor Bob Ross would say. You can even change something after it's published–Ernest Hemingway rewrote many of his novels after they were already selling. The point is to keep going and make the best of whatever you create.

In the beginning of their careers, many artists make a ton of things that don't work. They are inexperienced. They have never done it before. I like to think of proficiency in method, which is

usually where the rubber fails to meet the road in a project (not the vision), as like a language. If you want to learn French, there is a process. You learn a few words, then sentences, and one day you are speaking French to your grocer without realizing it.

There are a few very basic techniques that simply take some practice to master for almost all artists. Perspective, shading, and scale are foundations of setting and good balance, and are not as readily apparent to a beginner as color and feeling. In most cases, you really do need to learn to master these skills to render your vision from your head to any medium. How you do that is by actually practicing, which means making things that don't work. This is the time to evaluate what needs to happen next time.

When is the next time? NOW. This is especially true if you are feeling upset by something. Straight away, make something you can do easily and beautifully. I don't care if it is an origami dog or an ice sculpture; make a sudden success for yourself. This is not unhealthy denial, this is compensation and self-realization: *you have this*. Then repeat your unsuccessful piece if you have time. It's okay if it's not perfect, just ask yourself if it has changed? Does it look like a bird instead of a swing set this time? Can you tell it's a tree instead of a light pole, even sort of?

I must add a caveat to this—it should fill you with some joy to do this. You are creating, you are working, and you are feeling and thinking in a special world built by and for you. This should feel good. Don't, by any means, keep going over something that makes you miserable. Some pieces need time. Some need a dumpster! Would you rather spend a year making a wall straight or painting the lovely Tuscan landscape? Don't let

perceived imperfection slow down your artist mojo. Making the painting is far more important than making it perfect, for you and for the world.

Casual Magic: Bad Art We Love

I love Michael Godard, the guy who draws olives and strawberries whooping it up in Las Vegas. They remind me of velvet paintings, only gone wild. They are whimsical, funny, and technically well-executed. On top of that, I love that he started painting to deal with the pain of his daughter's death from brain cancer.

Although I am sure many a serious art critic rolls in his grave when I say it, I love Godard. And you can, too.

Pick some tacky, strange, unconventional, overly conventional, or downright strange art to love. Buy a postcard. Create some fan art by replicating one of their works or create a mash-up (like combing Star Wars and Godard). You never have to admit your guilty pleasure, but definitely set out to find some people who make a great living out of doing unacceptable things.

You know you love it.

Casual Magic: Refrigerator Drawing

Grab some crayons or ink pens and some white paper. Make a drawing for your artist that "they" can put on their refrigerator. Draw a Valentine or other holiday greeting, a picture of your family—including your fictional pet monkey and invisible alien friend, or the cover of your upcoming book of poetry dedicated solely to them (you).

Casual Magic: Acquire an Ally of Bad-ness

Everybody needs a friend, especially when they are down. Go out and find or make a new one who will be your champion of bad art. (Normally, I let my dog do this.) Find something funny, kitschy, or in supreme bad taste to keep in your creation space. It can be large or small, but it must encourage you to laugh when you look at it. Tacky tikis, Viking helmets (I have one for my dog), sparkly gel paint that goes with absolutely nothing, lava lamps, Hooters cups, whatever you like that makes you laugh. SOMEONE made that. And laughed all the way to the bank. Maybe you can, too.

What did you find? Can you see some of yourself in it?

Visit my website and check out some other crazy artist totems at www.daniellefournier.com/resources

Chapter 9

WHO YOU ARE AS AN ARTIST

He who jumps into the void owes no explanation to those who stand and watch.

—Jean-Luc Godard

You are one of a select few who answer to the name "artist." Who you choose to be as you inhabit that space is up to you. As a generator of content, a conjurer of creation, maker of many things, you get to define your path. Do not ever let anyone tell you who you are or what you will achieve. Once you own the title, it might surprise you how many people will project their fears onto you. From financial concerns to perceived lifestyle limitations, people will offer you their many honed and practiced opinions. Politely or not, say thanks, and walk away.

Having a mentor is a wonderful thing, and I love to help people along their careers. There is nothing like nurturing someone along their path. But the path is yours and yours alone. The path you choose is up to you because your real source of power comes from within. This is why it is called creation, not interpretation or regurgitation. At first glance, perhaps this seems lonely. It can be seen that way, but there are a million ways to define who you are by reflecting the world outside of you without taking it on or in.

Let me explain. As a creative person, almost anything you come into contact with on a daily basis can be used for creative fodder. Interactions, light, color, sounds, shapes, emotions–these are all raw materials for an artist. A bad day can give you a view on poverty, loneliness, frustration, grey skies, or whatever you take from it. A good day can inspire brighter colors, deeper love, tenderness, abundance, or connection in a way you have never seen. Some days you will want to hide in your craft. Other days you will post every stage of a work on social media. It all works, because that's how life is. You do not have to become ANY of these things without your permission.

That includes being "broke," "emerging," "good," "bad," "mid-career," "lauded," "ostracized," etc. As I once read on a bumper sticker, *Validation Is for Parking*. Finding out who you are as an artist is an evolving and lifelong process. You can have a north star, for certain, but you need only let that lead you where it will, through a lovely meadow that then leads to a dark forest or an icy wonderland. Your artist compass knows what it wants, and it will lead the way if you are willing to let it.

Self-defining is about learning how you work well and what keeps you motivated and happy. Finding out who you are doesn't mean self-limiting. If you don't let yourself do things that sound intriguing, say not trying acrylics because you are an oil painter, you lose out on an opportunity that could have increased your skill set and possibly made you very, very happy. And happiness is the point of it all, really. Your essential self needs to express itself and when it does, you will find yourself light, satisfied, and feeling like something big just happened to you—because it did.

Honoring who you are and what you really need to thrive is not only a huge part of a healthy emotional life, but also a huge part of creating a system of practice that works for you in the best way possible. How you see yourself is crucial here. Gently, very gently and honestly, ask your artist how they see themselves. Are they a wild rogue full of daring, slashing and ripping canvas as they bring some demons to light (which is just fine), or are they happier in a meadow quietly dotting wildflowers into watercolor scenes, humming like Snow White? Do they want to pack it all up into a rustic sack and do a plein air trip of Europe? Do they like a tidy studio full of sharpened pencils and scheduled bouts of work? It doesn't matter how you work best, but that you find out how you work best.

Personally, I love to work, uninterrupted for two hours or so at a time, take a break (especially with food or a walk), then head back to work for two or three hours. It depends how well the work is going. I like some structure, so I always start studio time about 10 a.m., just when I think the light is good enough to see by in winter and not too hot in summer in front

of my living room window. I cannot paint in a darkened room, even with adequate lighting. I found this out when I took advantage of a cheap studio space offer. It lasted a week or two. I just didn't like the space. It was cold, lonely, and suffocating. My ideas dried up and I quickly found my days were spent avoiding my new space. Back to my window I went. I liked, and still like, having my creation up to look at even when I am not working. It gives me ideas. I see how it looks different times of day. I see it more like the audience does, I think. I also have a playlist of music that works. I have tried too many to list, but it's usually either a beachy guy like Jimmy Buffett or opera. I have tried other stations, but I always come back to stuff I have heard over and over. I don't change it up much because it WORKS. The one element I wish I could change is that I wish I was able to work with people around—it would make life and relationships easier. But I haven't found a way to do it yet.

The point is that I know through experimentation how I can set myself up for an easy day's work. I know what time of day, how long, with whom, and where I like to work. I know I need a warm up, free of expectation. I also never quit on something I hate. And I always break for a sit-down lunch, just like when I had an office job. Because it makes me feel great!

You can create whatever system you need. If you don't have a studio space, start small. Ask yourself, do I need quiet? Or some noise? Or a crowd? Do I like long periods of creation or short bursts? Do I like to work fast or slow? Organized or messy? One color or lots of colors? Do you need pictures or do you like to start from your mind's eye?

If you don't know, ask yourself about a time when it felt like it went right when you were creating. Describe the situation, environment, setting, mood, and emotion. Try recreating that scene to work in. (Heavens knows, you can surprise yourself. I once wrote a book on a Blackberry while travelling through Europe for 10 weeks. It started as emails home and became a travelogue. It was noisy, full of people, and erratic—the exact opposite of what I like to create for myself on a daily basis. So, you never know.)

Do you like to make art with others? This can be fantastically rewarding and fun, and potentially devastating. If you decide that you want to make a project with others, consider why first. Collaborative work is wonderful, difficult, and can be time-consuming and stressful. Knowing that, make sure you are not seeking permission or validation. Ask yourself how you work in a group, if you ever have. Are you the leader, are you an outlier, or are you a diplomat? Do you know the others in your group? How are your working styles different? Are you all working towards the same goal? Are there friendships on the line?

Asking these questions at the get-go can stave off all manner of unwanted outcomes if you are prepared. It also opens up a whole new world if you get in with some like-minded people. There is nothing, I repeat nothing, more awesome and energizing than being all-in with your peers. You co-create as if you are a family, a hive, or a long-standing acting troupe. It's fantastic. It's epic. If you have this kind of experience, the one that connects you to your tribe and is deeply fulfilling, you will never forget it. I guarantee you will continue to seek the experience out.

As an emerging artist, it might be hard to pinpoint that opportunity right off. There are many ways to start working with other people where the stakes are low. Many cities now offer something like "paint and sip," a social event where painters and non-painters alike gather to paint the same scene with instruction–and usually libations! These are wonderful ways to meet other creative people. Some people will be self-declared artists, others will be hobbyists, and some will just be along for the ride.

Another place to get out in public and do some art with others is to take an art class at your local supply store, gallery, studio, or school. Again, it will be a mix of serious searchers and hobbyists, but with more varied instruction and media. As with any instruction, be mindful of the feedback you get. Do your research about the instructor if you can to ensure a good fit. If it ends up not being a good fit, try to take what works and leave the rest. (I once had a teacher who insisted I did not reference my photo enough; that I got "caught up" in my work. I kept losing the shape of the landscape I was painting as I focused on creating my version of the scene. I hated the chiding; it drug me from my revelry. Eventually, I thought she was right because I was trying to recreate a lifelike scene, so I took that to heart and applied it. At the time, though, I really resented her chiding.) If it is truly awful, simply leave and admit it was not a good fit. This isn't likely, but it does happen that a student and teacher do not gel. It's simply an outlook issue and you need not worry too much about it–even if they said that their pet monkey can draw better than you.

The point of working with others is to share, commune, and collaborate. If your being in the presence of others, especially if you are sharing the burden of a project, makes you tense, tired, or blocked, give it up. That doesn't mean quit when you don't get your way. That doesn't mean you will "always be alone." It doesn't mean the life of an artist is selfish or lonely. It means you just shouldn't do this project. Maybe forever! But probably not. Chances are, you will do some work with people, some work alone. It's guaranteed that if you enter any commercial sphere, you will be working with a whole lot of people. At that point, you need to know how you work well, how to be professional, and how to say exactly what you need to fulfill your contract without becoming a diva. That all begins with knowing who you really are as an artist.

Casual Magic: 30-Second Elevator Pitch

My name is Danielle, I paint abstract animals and sea life in crazy colors. Kinda like Wyland on crack. I paint under my Hawaiian name Lehua, it's the flower that grows on the volcano. What do you do?

I just gave you my 30-second elevator pitch. It says I am loud, kind of weird, and into Hawai'i. It's a make-or-break statement. People either get interested, or mumble, "interesting… and drift away. Either way, I know who I am and I am not budging.

As you develop your artist identity, start thinking about how you will introduce yourself. People will for sure ask what your medium is, how long you have worked, and basically if you make money at it. You can answer all or none of these questions, but you will be most comfortable if you have some handy answers,

especially if you don't want to talk about intrusive topics like sales. Don't let anyone put you down; you deserve better, and when you are young, it can feel very vulnerable to tell people you are … working as an artist. Here are some questions you will encounter and some canned responses. Try them on for size and tailor to you comfort level:

Question: What do you paint?

Answer: Animals, flowers, abstracts, people, hyenas, lizards on vacation, whatever

Question: Do you sell your work?

Answer: YES is the only acceptable answer if someone asks you this question. Because then they might ask…

Question: When (or how much) was your last sale?

Answer: How about now? Want to see my work? I have it right here (phone, business card, app, or just carry around a canvas)

Question: Do you make a living at it?

Answer: Yes, no, hope to, or my fave, a smart-mouth *Did Ghandi? He did it for love and his people! Begin polite tirade about occupations and the meaning of life…*

Question: Who have you studied with?

Answer: Wow, too many to list, I'm self-taught (let them figure THAT out)

Question: How long until you quit/get a real job?

Answer: Feel free to cry and ask them for more advice, especially regarding your love life. Or say, this is it for me, I am happy. Which, hopefully, is deeply true.

Question/Statement: Artists are crazy.

Answer: So are lots of people. Don't you think? Pretty sure
I am sane enough to have this conversation or they just
let me out today, how am I doing?

The list will go on and on. Don't ever let it get to you. Some
people will do it on purpose, some will just be ill informed
about your life. Ignore it, but be prepared to gently protect
yourself in whatever loving way you see fit. Don't be afraid to
stand up for yourself!

Create an introduction that you can use in almost any
situation that describes you, what you do and contains some
kind of insight. Practice it next time someone asks you what
you do. Notice the questions that bother you, or stump you.
Get clear about where you feel defensive or vague. Refine as
necessary until you introduce yourself with ease and comfort
knowing that you spoke the truth, the whole truth, and nothing
but the truth.

Casual Magic: Live Your Perfect Creative Day

Design your perfect day. Write down how, when, and where
you work. What do you do? Who are you with? How long is
your working day? How much gets done? What supplies do you
have? What do you do after? Before? What's for lunch or dinner
if you like to work nights? What are you wearing? Is it quiet?
Outside or in?

Choose one day this week you get to live it. Did it fit? Was
it awesome or did it need some tweaking?

Casual Magic: The Perfect Pajamas

Forgive me for sharing, but I once spent an entire month wearing the same pink Paul Frank pajamas. I would rise, shower, and redress in my PJs. Before you think this was when I was once deeply depressed, you need to know I was doing NaNoWriMo, the National Novel Writing Month challenge where you create a short novel in 30 days. It was hands-down the happiest month of my life. I barely slept, I wrote all day (which was easy with my job as a publisher at the time), and I made quick, fun food that I really loved because I was too happy writing to even do anything else. Yes, I did WASH those PJs, but they went right back on. My inner artist loved them. They had happy monkeys all over smiling up at me from beneath my laptop. Every word, every phrase I wrote, every day I ticked off another 1,667 words, they cheered me on. They were perfect.

Go find some perfect pajamas. Are they silly, fuzzy, silky, short, long, big, hot pink, your significant other's or do they match your pets? Wear them when you create. Or after you have created something you love.

Want to practice your elevator pitch on me? Upload it to my site and I will give you some feedback. Go to www.daniellefournier.com/resources and click the link for *elevator pitch.*

Chapter 10

MAKING MONEY

Money is a terrible master but an excellent servant.
—P.T. Barnum

I f you are serious about a creative life, at some point you have either thought about or have tried or are charging for your work.

This seems basic enough. Make something, name a price, and bring it to market. There's only one problem: you are selling yourself, in more ways than one. Knowing that, it's best to be prepared from the get-go.

Whether you are selling, not selling, or somewhere in between, it's good to assess if you should even be doing that from the start. Does the mere mention of art and cash in the same sentence make you break out in a sweat? Do you feel it

devalues your work? Do you think you shouldn't charge for your work? If the answer to any of these questions is yes, maybe it's not time to sell your creations. Let me explain.

Although I deeply feel that all artists should be paid well and fairly for their work, I also know that there is a time to take the pressure off. Making art for money can present an array of pitfalls.

First and foremost, if you feel getting paid will validate whether you are a) good enough or b) going to make it, you should stop right there. There are lots of reasons people buy art—setting, time, price, etc. If you don't evaluate your business plan from the perspective of making a solid commercial endeavor, you can expect some hardship and some heartbreak.

Let me share my first experience doing an art show, the way many people sell their art. I bought a display set-up and a tent first thing (not cheap). I wanted to look professional. I also wanted to hang my work, so I added hangers for frames (more money). I applied to a very expensive, sure-bet series of shows to which I got in. Other people raved about it. I signed up for the entire season, proud and excited to be included. I was also certain I would make money. Then I had my first problem: pricing.

I had no idea of how to price my work. I did something kind of different and didn't have any reference of another emerging artist to base it upon. I made my best guess and priced it on materials plus what I was willing to let it go for. This was tricky, and ended up producing a widely varying price structure. I tried to be fair, but I had small ink on paper butterflies as well

as giant oils on canvas and detailed turtles. I figured I would haggle and be okay.

It was SO not okay. People at those kinds of shows have expectations. Not necessarily real or reasonable expectations, but expectations nonetheless. They are frequent attendees and they have seen everyone else's prices. In no way am I saying you should let the market tell you how to price, but be ready for a fight if you ask $5,000 for a 24 x 36 canvas by an unknown. It will make for a long day of lookers who don't buy.

I did have one amazing experience the first morning, and I will never forget it. A woman walked by my booth, stopped, and gasped. She stood there and just stared. *How much for the angel, she asked.* I told her the price (I got this one right I think), and she handed over her card. It then hung in her *restaurant* until she moved to another part of the country.

I will never forget that first totally unsolicited sale. It was magic. It was validating that my work was touching to someone else (heck, I loved it) and *she* loved it enough to give it welcoming spot where it greeted diners as they entered her establishment. Sometimes I would go to her street and just walk by to see it hanging there, making people happy. It was an awesome feeling. Oh yeah, and I got some money to buy more supplies.

The rest of the series was torture. I have a retail background, so I could talk to customers, but it was difficult to ask for the sale all day, every day. What I really wanted to do was paint. I was defensive if people wanted to haggle. I was hurt when they didn't buy. The hours were long, blah, blah, blah. It was definitely not my gig.

On the other hand, I met two people at the shows that were thriving–really thriving. They loved people and felt very comfortable closing the sale, much like a car salesman. They were witty, full of banter and could read a ready buyer. One told me he sold 100 pieces priced at roughly $2,000 a piece at one premier show each year he attended. Another shamelessly carted in only three $5,000 home-built boards covered in glossy acrylic abstract from his '78 Chevy van, and sold two in one day.

I learned a fast, hard lesson about selling. I spent a lot of time and money doing something that was a bad fit for my personality. My art feels like a part of me, I prefer intimate groups of people, and I have a radical sense of color, all of which roughly translated to: *Introvert. Selling. Her. Children. to. Golfers. Who. Like. Beige.* I wouldn't say it was a bad experience, though. The shows were beautiful and well run, I met nice people, and I learned a lot of things about myself and my audience in that season.

The most valuable thing I learned was that what I loved most, my crazy birds of color and my angels, were what children ran to. RAN to. They would drag their parents to see the turtle, the butterfly, the monkey. I am not bragging, I am totally touched that someone *got it*. This lead me to start developing children's art. Which is super easy to sell in small sizes on the internet, but more about that soon.

There are basically three reasons not to sell your art: if you let it determine your value as an artist, if you love your art too much, or if you undervalue it. There comes time when you must detach from your creation and set it free into the wide

world. If you can't, don't sell it. (Or just make a print so you can keep the original). If you let your personal value set the price of the art, the chances are you will sell it too dearly or too cheaply. Neither serves you or your work. If you want to practice on something for free, tell your potential client that up front. You are willing to play with it, and if they like it, they can buy it. It's low risk. Sell pieces at prices you think are truly reasonable, but never undersell yourself, no matter how new you are. If you sell something and it makes you feel sad or angry, you have charged too little.

Now, what happens if you feel the piece IS worth a hefty sum? Well, you can either create a market for it or wait on it. The choice is yours, but realize that people buy what they feel is valuable to them. And maybe you will have to wait a while on that sale. And though there are a hundred examples of sloppy, amateur, off-the-cuff pieces that get a great price, there are thousands of others sold for exactly the opposite reason- they are inspiring, evocative, well executed pieces. This is where the majority of art sales truly fall.

So, don't let your cousin talk you down from $400 to $40 for your painting, nor should you charge $1,000 for a miniature of your cat that *the cat helped you paint* (unless you can get that!). Find a nice middle ground.

This is not settling, this is testing the waters. See how your first foray in sales goes. If it feels good on all accounts, keep on going! If it makes you blocked, sad, angry, discouraged, or frustrated, wait a while. Perhaps you need more research to build your style of selling. Or maybe your energy is off regarding

selling your art. Whatever the cause, do some digging and see what comes to the surface.

Putting pressure onto your art to feed you can have some serious side effects. It's a lot of pressure on your artist. Not to say that you shouldn't do it, but consider whether or not it shapes how and if you create. Some of us want to make a living doing what we love, so we can live it every day, all day. But sometimes you can scare that creativity away with massive pressure to perform, and create a huge block to that life sustaining creativity. As Elizabeth Gilbert says in her book, *Big Magic: Creative Living Beyond Fear*, "… to yell at your creativity, saying, "You must earn money for me!" is sort of like yelling at a cat; it has no idea what you're talking about, and all you're doing is scaring it away, because you're making really loud noises and your face looks weird when you do that."

If you do decide you want to do it, here are some easy ways to test the waters.

Five Ways to Make Money with Your Art Online

Social media has opened up a whole new world for selling just about anything online. It gets easier and easier to bring products to market without much expense or effort. In many cases, it's as easy as posting a photo.

Here are a few of my favorites:

Facebook—This is the fastest easiest way to sell your art online. Post a photo of your art with or without price (depending on what feels right) and some details like size, media, and details on subject. For an example: *Octopus Prime, 18x24, Oil on Board $400. Painted from my latest adventure*

to Maui, where I reignited my passion for saving the ocean. Did you know they turn different colors?! I truly recommend taking a picture in stages so it shows progression, and makes it harder to just copy and print. If you do put up a finished piece, watermark it, be sure it is signed, and make the lighting or angle a little bit off. (I always photograph on my easel with the overhead light on, it leaves a halo that's annoying, but not too distracting.) Another way to promote on Facebook is to record video as you work. People LOVE seeing your process, even if you are not selling what you are making. You can also target people with ads and promote the post, but you will get your most mileage from just sharing intriguing work and making as many friends as possible. If you want to separate your personal from business, do so. You can also create a business page, but I haven't found that to feel as authentic. In the end, people are buying you as much as your work, and they want to feel connected to you. Interacting authentically will bring your fans closer to you. And then they will buy. (I highly recommend getting a Square or PayPal Here credit card reader in addition to a PayPal account, all of which makes online sales a snap.)

Instagram—Who doesn't love the luscious feed of Instagram photos? What's even greater about Instagram is you can hashtag your work and get new followers easily. You will also be exposed, if you keep your account public, to many new people who do not need to be your friends like on Facebook. It's great exposure. I would avoid using too many cool filters though, unless you are just promoting work, because you will not be delivering what you are showing, which is very bad indeed. If you have a website or blog, list the URL in the caption. (Send your audience to

your feed, and, ideally, get them on your email list. These are your best clients! They love you and are interested. Treat them as VIPs from the beginning.) With apps quickly integrating into Instagram, selling gets easier each day. Google "sell on Instagram" and see what pops up for current offerings.

Blogging—It never seems to get old. What's wonderful about blogging is that you create a relationship with readers and, again, ideally build an email list of people who are interested. Your blog is a great place to explore your ideas, develop your artist identity, and show your work. You can use it as a sales platform with buttons to buy your work. You can share your posts to other social media with a click. You can also turn up in Google searches if you get savvy about Search Engine Optimization (SEO), which exposes you to the entire world. Sites like Wordpress.com, Blogspot.com and Sitebuilder.com make websites and blog design faster than ever, and pretty easy. They are relatively inexpensive or free, depending on the level of service you choose.

Etsy—If social media is not your gig, try Etsy, the craft marketplace. One caveat is that the reported value of the average sale on Etsy is $30. So, if you have work in the under $100 range (like prints, cups, tees, etc.), this could be a great place for you to try. They do charge a small fee per listing and sale, under $1 in most cases. There is an easy-to-use app, and you can go live in a matter of minutes. The exposure is good, and the site is searchable.

Fine Art Sites—Saatchiart.com and Fineartamerica.com let you upload your work and set a price, then they take a percentage of the sale. On the plus side, people do actually buy

expensive, large, and heavy works on these sites in a huge array of subjects and mediums. Fineartamerica.com carries originals as well as tons of ways to sell it in popular forms like prints, canvas, totes, and phone cases. Saatchiart.com sells originals only. They take a 30% fee, but it's a one-stop shop for sales and shipping. They have a global audience, and have a history of moving all kinds of work. If you want to solely sell your originals, this is a good bet.

The Gallery Scene

Many artists want to hang their work in galleries. The gallery scene is as vast and varied as artists themselves. The galleries range from upper echelon venues featuring established artists that command high prices to locally run artist co-ops. Galleries typically charge 20-40% of the sale price when they sell your work. Many co-ops require the artist to work the floor in trade for a lower commission. Your best bet if you want to show in a gallery is to develop a relationship and come ultra-prepared. Some, not all, galleries will give walk-in portfolio reviews. However, it's best to do your homework, call, write, or do a web search for their representation policies no matter how small or large the gallery. Find out whose work they currently represent. Are you a good fit? If they are known for abstract, it's not likely that they will take on a realist. If they are reviewing new artists, make good representations (photos or prints) of your work and either bring them in in a neat binder or on a tablet. Make sure your presentation skills are adequate-practice on a friend if you need to. Be able to introduce yourself (see Elevator Pitch exercise), have your prices ready, and bring a "leave behind" like

a business card or rack card (see inexpensive, sharp sites like Vistaprint.com that carry short runs of cards where you can put your work on the back side). If you have an appointment, be on time. Get in with the goal of getting out. Do not take too much time, nor argue if they refuse your portfolio. If they ask you to leave it, make sure to schedule a check-in and retrieval date. If they don't offer a time frame to look at it, a week or two is adequate. If they haven't looked at it in over 30 days, just drop by and pick it up with a thank you. They will remember you as professional, and maybe your work will fit at another time or they may know someone for whom it's a good fit.

Competitions, Shows, and Grants

This last category can be very competitive and yield slow results for sales, money in the form of prizes, and grants, but it's good to look at these options because there are some real opportunities for career advancement, notoriety, and connection. Competitions are good if you know it's a good fit. Look at previous years and see what is winning. Shows, especially statewide shows like fairs, art societies, or cultural councils, can be inexpensive and fun way to get your work seen by people in your area. Becoming known as the local artist, even just on your block, is the beginning of getting your name out there. Grants are competitive, but if you truly have a socially conscious mindset, you can find money to share your art with children or elders, spruce up downtrodden areas, make political or social art, and even start schools. The timeframe for most grants can be long, months or years, but some of them are LARGE, so make sure to look around.

Search "[your state] arts council" and see if your state has a good website devoted to all the calls, opportunities, state grants, and even jobs. If you live in a different state (or country) than your subject matters, sea life in the prairie states, for example, search a state you think might have offerings for your subject. There are sites like www.callforentry.com and www.entrythingy. com that have nationwide and even worldwide calls for art. Some are free, some are cheap, and some are expensive to enter. Have a look around and you will find there are literally thousands of options to consider.

When to Quit Your Day Job

This is tough. Ideally, when you can pay all your bills with your work, stress free. I mean that, stress free. However, I can say I have seen people get their motivation by making the choice to do their work full time. Should you do it if your doghouse has a mortgage? No. Should you do it if you have little or no business experience? Not yet. Should you do it if you have six months' savings, little debt, and your significant other is supportive? Probably yes. I can't tell you when is the right time, because it has a lot to do with how much security you need, how willing you are to hustle, and your financial condition. It should be a happy, freeing, beautiful decision that makes your face hurt with happiness. If not, just sell on the side for now. Slowly increase sales until you are ready. Doing something else to pay the bills is a service to your artist, and you should not ever consider that to be a failure of any kind. It's a grown up, responsible thing to do, taking loving care of yourself.

Making money from art isn't always easy, because it's self-employment. Ultimately, it's very rewarding, assuming you follow your inner guidance and honor your needs. Be open to exploration, and don't take it too seriously if it goes slowly or even not at all. You are always learning, after all. And your artist really is okay with that scenario.

Are you interested in learning more about art marketing and sales? Visit my website www.daniellefournier.com for more information and links.

Casual Magic: Sidewalk Art Sale

Fashion a lemonade stand for your art. Draw, paint, or create whatever you like. Set up a table, cardboard box, or other surface. Make a sign: *Art $5*. Only sell pieces that fit under this category. Make a new series if you need to. Haggle or not. Talk to strangers. Bring a friend. Have fun. Quit when you are ready. Drink a lemonade. You are now a professional artist.

Upload your photo to my site at www.daniellefournier.com/sidewalksale for a free gift, and a little fame.

AFTERWORD

So this is how you swim inward. So this is how you flow outwards. So this is how you pray.
—Mary Oliver

Your artist will thrive under your love. The world needs your art, and you need it just as much.

Make choices when you are really ready, not when others tell you it's time. You know yourself best, and you will know when the time is right. Don't let anyone ever tell you how to do your art, you know just fine, thank you.

Your artist knows what it needs. It's time to listen. You have a beautiful, unique, singular gift. You are lovely, perfect and whole. No one ever has to validate a damn thing of yours, ever.

Take what you love and leave the rest for the birds. The only thing that matters is to keep working, gently, kindly, and on and on until you return to the heavens.

Whatever happens, happens. It's cliché, but it's true. Maybe you will be famous, maybe not. Maybe you will get paid, maybe not. What matters is that you follow a trail of happiness that you forge with insight, passion, and peace.

Your artist knows what it needs. It's time to listen.

ACKNOWLEDGEMENTS

This book would not be possible without the love and support of many people.

To my badass family, who make life fun beyond words: John, Lucinda, TJ, Chas, Mom, Matt, Megan, Tory, Tabor, and Ellery. I am finally living Gram's vision.

Thank you my friends: Kelly "Madame K" Godell, for the late night calls. Maggie McReynolds, for being patient and laughing with me. Angela Lauria, for calling my bull when I was really scared. David Fischer, for listening to all my… everything (over and over). Amanda Tallman, for just saying no. John Fournier III, for taking a risk on me. To my dragon sisters–I never feel alone around you: Alex, Hilary, Tarrone. Duke Oliver, the best arguments are yet to come, my friend. To Kathleen Dean Moore, who brought me back to writing.

To my staff for patience with the process; I learned to be a better publisher being on the other side of the table. Tory Garcia, for your take-no-prisoners approach to life. Palmer Malarkey, for your smile, no matter what. The Stone House Inn, you gave shelter in a storm and reminded us what love is. To Chris at Vintage Coffee, for the WiFi and chatting when I was "procrastinating."

And to my family of newspapermen, it all started when a crazy French Canadian bought a paper on a whim after college. The ink is forever in our veins, with new formats, new beginnings, and an enduring passion to serve our communities.

Thank you, everyone!

ABOUT THE AUTHOR

Danielle E. Fournier is an author and third-generation newspaper publisher, as well as an accomplished painter, photographer, and musician.

She has a passion for helping other artists unlock their potential through humor, self-inquiry and authenticity. She

teaches other people to not let their fear hold them back by gently reminding them to be boldly authentic in their creative nature.

Fear is something that she feels she has a special relationship with. It held her hostage for years emotionally and creativity. After getting off airplanes for years, she overcame her fear by learning to fly, an act that immediately offered bravery in all other areas of her life. A former anxiety sufferer who rarely spoke, she has now travelled to 41 countries, performed solo onstage, recorded two CDs, exhibited her work in galleries and shows, and creates *something* every day.

"It is my sincere wish to see every artist embrace their creativity as the divine gift that it is," she says. Artists, she feels, have a special mission to remind us of our humanity, our beauty, and our ability to heal all things with the love of creative actions.

She holds an MFA in Creative Writing from Full Sail University, a private media arts school in Florida. She has written three novels, eight short plays, five children's books, one feature-length film, and two non-fiction books. She lives in the Pacific Northwest.

THANK YOU

Thank you!

Thank you so much for reading *The World Needs Your Art.* I truly hope you are feeling your creative talents coming to life, and that the future holds much, much more in store for your art.

Please visit my website to download a free class on getting started as you start practicing Casual Magic of your own: www. daniellefournier.com

A free eBook edition is available with the purchase of this book.

To claim your free eBook edition:

1. Download the Shelfie app.
2. Write your name in upper case in the box.
3. Use the Shelfie app to submit a photo.
4. Download your eBook to any device.

Shelfie

A free eBook edition is available
with the purchase of this print book.

CLEARLY PRINT YOUR NAME ABOVE IN UPPER CASE

Instructions to claim your free eBook edition:
1. Download the Shelfie app for Android or iOS
2. Write your name in **UPPER CASE** above
3. Use the Shelfie app to submit a photo
4. Download your eBook to any device

Print & Digital Together Forever.

Snap a photo

Free eBook

Read anywhere

www.TheMorganJamesSpeakersGroup.com

We connect Morgan James published
authors with live and online events
and audiences whom will benefit
from their expertise.

Morgan James
Speakers Group

Morgan James makes all of our titles available
through the Library for All Charity Organizations.

www.LibraryForAll.org